S0-CAB-061

Newport Beach

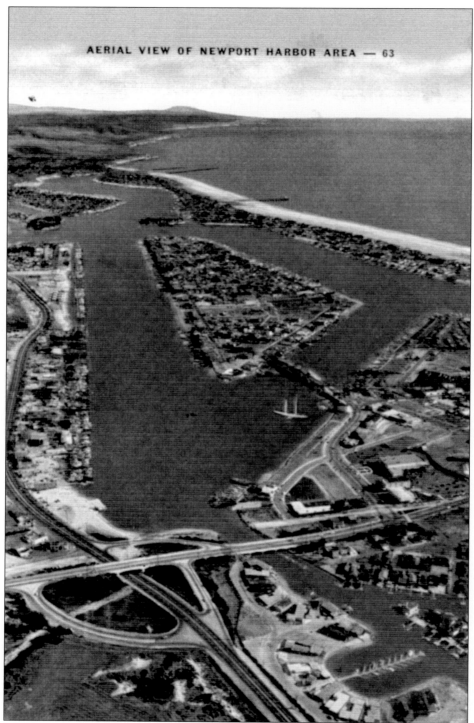

AERIAL VIEW OF NEWPORT HARBOR AREA, C. 1944. This image shows Newport, Balboa, Balboa Island, Corona del Mar, Lido Isle, and Pacific Coast Highway.

POSTCARD HISTORY SERIES

Newport Beach

Jeff Delaney

ARCADIA

Published by Arcadia Publishing
Charleston SC, Chicago IL, Portsmouth NH, San Francisco CA

Printed in Great Britain

Library of Congress Catalog Card Number: 2005929124

For all general information contact Arcadia Publishing at:
Telephone 843-853-2070
Fax 843-853-0044
E-mail sales@arcadiapublishing.com
For customer service and orders:
Toll-Free 1-888-313-2665

Visit us on the internet at http://www.arcadiapublishing.com

This book is dedicated to my wife, Julie, who, years before we were married, offered the best advice I've ever had the pleasure to receive. "Dude," she said earnestly, "you've got to move to Newport."

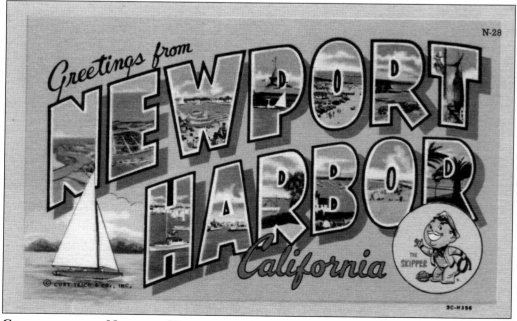

GREETINGS FROM NEWPORT HARBOR, C. 1953. In 1958, a charter amendment to change the city's name to Newport Harbor failed to be adopted.

CONTENTS

ACKNOWLEDGMENTS

The author would like to thank the following publishers for producing not simply postcards, but a photographic history to be cherished for generations to come:

Balboa Pharmacy
Benham Company
Colourpicture
Craftsman
Curt Teich and Company
Detroit Photographic Company
Drown News Agency
E. C. Kropp Company
Frasher Foto Company
Geo. P. Wilson
George O. Restall
Gilmore Photo Laboratory
Golden West Color Card Company
H. S. Crocker Company
J. Bowers Photo Company
M. Rieder, Publishers
M. Simberg
National Press, Inc.
Neuner Company
Newman Post Card Company
Royal Pictures
Souvenir Publishing Company
SUB-POST Card Company
Tichnor Quality Views
Western Publishing & Novelty Company

INTRODUCTION

At the time of this book's publication, Newport Beach, "where the ocean meets the bay," celebrates its centennial. What better occasion to look back at the people, places, and events that brought us this far.

While 1906 was Newport's year of incorporation, its beginning lies decades earlier. In 1865, the Civil War was coming to its violent, bloody conclusion. President Lincoln lost his life to an assassin's bullet. Across the nation, there was a sense that, for right or wrong, everything was about to change.

It was during this time that S. S. Dunnels, a true man of the sea, ran a small, flat-bottomed, side-wheeled steamer named the *Vaquero* up and down the California coast. On numerous occasions, he was tempted to investigate a quiet body of water that lay between a long, narrow sandbar and cliffs to the north that extended several miles along the coast.

Finally on an especially calm, clear day, he decided to "put in" and explore a bit. After negotiating the bay's treacherous entrance, he found himself on a placid, mile-wide body of water. Following its twists and turns, he tied up at a deep inlet just below the present intersection of Dover Drive and Pacific Coast Highway.

Upon his return to San Diego, Dunnels proudly declared his discovery of a "new port." The story of Newport Beach had begun. A landing was established at that same deep inlet, and a wharf was built. The *Vaquero* made numerous, highly profitable trips to Newport, picking up grain, hides, and livestock from James Irvine's San Joaquin Rancho.

In 1868, James and Robert McFadden of San Francisco purchased 5,800 acres of the former Rancho Santiago de Santa Ana. Five years later, the brothers shipped a consignment of fence lumber into Newport Bay, intended for their own use. Instead, they sold the lumber at a significant profit to settlers moving west. Sensing an opportunity, they sent another shipment, soon followed by a third. Before they knew it, the McFaddens were in the lumber business. The brothers purchased the dock and small warehouse in Newport's upper bay, which came to be known as McFadden's Landing.

By 1876, three sailing schooners, as well as the McFadden's own steamer *Newport*, were placed on a regular San Francisco–Newport schedule, carrying lumber south from the Bay Area and returning north with a shipment of Orange County's bountiful agricultural produce.

But the harbor entrance remained treacherous, and numerous accidents occurred. Upon the death of their good friend, Tom Rule, the McFaddens finally decided an ocean pier was necessary. Construction began in 1887 and was completed the following year. The first ship to moor at the new pier was the *Eureka*, and as she tied up at midnight, she blew a blast on her

whistle to signal the event. Over the course of the next year, 72 vessels unloaded their cargoes over the new pier's deck.

The McFaddens intended to build a railroad to Santa Ana concurrently with the pier construction, but as a result of delays, the first train over the new railroad didn't run until January 12, 1892.

By 1899, the high cost of pier maintenance and repair placed the McFaddens in a receptive mood for an offer on their property. James McFadden never would have knowingly sold to the Southern Pacific Railroad but was tricked into doing so by Col. W. H. Holabird, who is believed to have been acting as an agent for the SP.

The SP, wishing to promote the wholesale business in the harbors of Los Angeles, likely purchased the Newport pier and railway with the intention of killing the industry they supported. As a final blow, the Southern Pacific raised wharfage rates on lumber at Newport to a prohibitive figure, forcing vessels to take their cargo elsewhere.

The last commercial shipment to unload at Newport was from Australia in January 1907. Four year later, the SP had the outer 144 feet of the pier removed to save on the cost of upkeep. Newport's days as a commercial interest were over, but her future as a pleasure harbor had begun.

The McFaddens, disgusted with the manner in which they had been tricked, withdrew from Newport in 1903, selling 500 acres to W. S. Collins, a former realtor from Riverside, at a price of $35,000. Collins, operating under the name of the Newport Beach Company, subdivided the property in maps submitted in 1904–1905. As many as 48 realtors as well as train loads of prospective buyers immediately converged on the scene.

Fast forward to the early 1930s. George Rogers, whose son had lost his life at the still treacherous harbor entrance, read of the New Deal's National Recovery Act and set off for Washington, D.C., with city engineer Richard L. Patterson in tow. The pair won the endorsement of the Army Corps of Engineers, and on January 24, 1935, the headline of the *Balboa Times* read, "Newport Harbor to be Yacht Harbor of the World!" The accompanying article spoke of a brilliant future for Newport, dazzling in its scope. With the aid of Sen. Hiram Johnson and Sen. William McAdoo, Rogers and Patterson had secured $2 million for harbor improvements. The same article optimistically predicted a future year-round population of 12,000 in Newport.

Today, as we celebrate our centennial, 80,000 residents proudly call Newport Beach home. Tourists come from all over the world to enjoy our beaches and harbor. In the chapters that follow, the postcards tell the rest of the story. Some of their subjects have long passed into history. Many others remain to this day, reminding us of the people, places, and events that made Newport "the crown jewel of the Pacific coast."

Enjoy, and welcome to the beach!

One

BEFORE 1910

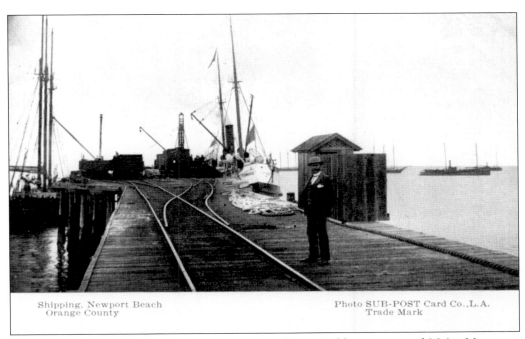

Shipping. Newport Beach
Orange County

Photo SUB-POST Card Co.,L.A.
Trade Mark

SHIPPING, NEWPORT BEACH, C. 1892. In 1887, the McFaddens contracted Major Marner to construct the Newport pier. It was completed the following year. Initially its piles penetrated the ocean floor only eight feet. In 1892, a tremendous storm almost wrecked the structure. The pier, rebuilt in two-months time, had a pile penetration of 15 feet.

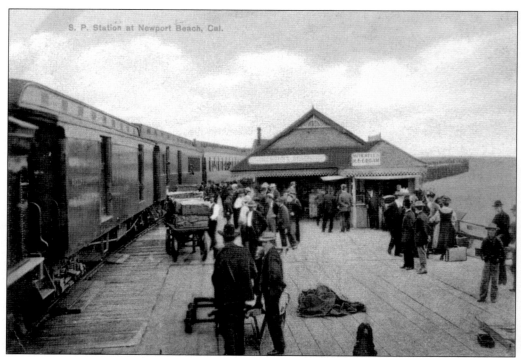

SP STATION AT NEWPORT BEACH, C. 1908. The Newport Railroad was built by the McFaddens and Joseph Bright and Company. The first train over the tracks ran on January 12, 1892. In 1899, the railway and pier were purchased by the Southern Pacific.

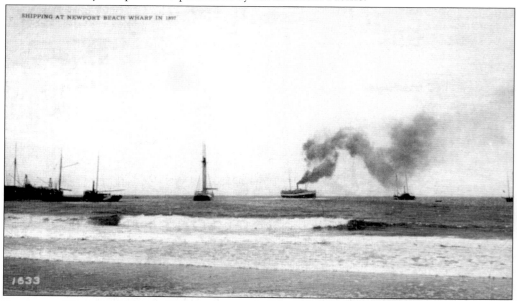

SHIPPING AT NEWPORT BEACH WHARF IN 1897

1633

SHIPPING, NEWPORT BEACH WHARF, 1897. The chief freight items on the Newport Railroad were incoming lumber and outgoing barley from the Santa Ana Valley and the San Joaquin ranch of James Irvine II. In one year, as many as 550 cargoes were discharged in whole or part by over 100 workers at the Newport pier.

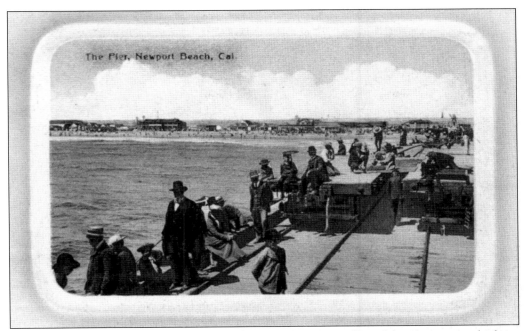

THE PIER, NEWPORT BEACH, C. 1905. In 1892, when 600 feet of the pier was washed out by a storm, three Santa Fe flat cars, similar to those pictured here, went overboard. Two of the cars came ashore rather quickly. The third washed ashore on April 15, 1915—a quarter of a century later.

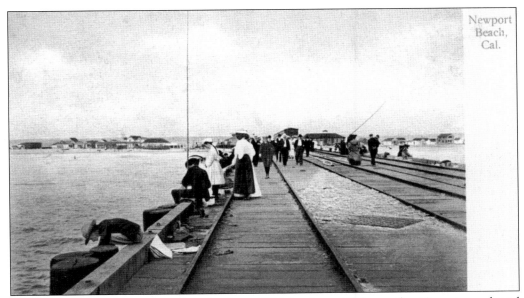

NEWPORT BEACH, C. 1906. The wharf was 1200 feet long, 60 feet wide at its outer end, and 19 feet above the water at high tide.

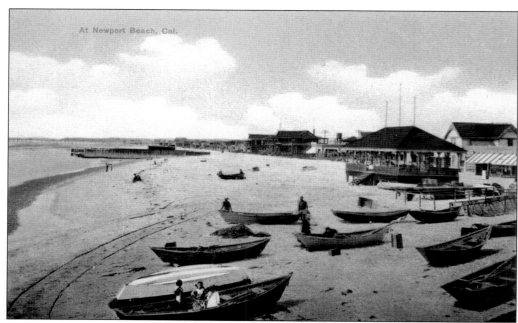

NEWPORT BEACH, C. 1908. The dory fishing fleet was founded in 1891 and continues to operate today in its original location, just west of the Newport pier. It has been designated a historical landmark by the Newport Beach Historical Society.

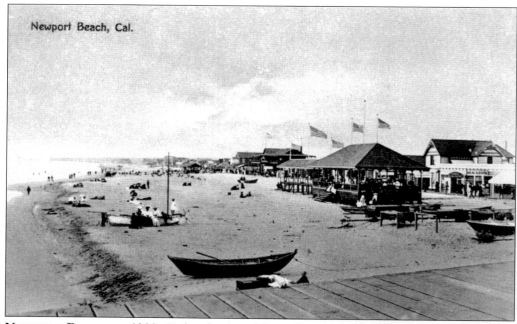

NEWPORT BEACH, C. 1908. Today the dory fishing fleet zone is delineated by pilings erected by the city and is reserved for full-time dory fishermen, who derive their livelihood from commercial fishing.

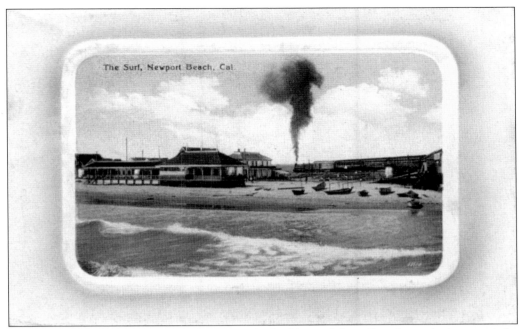

THE SURF, NEWPORT BEACH, C. 1905. The building of the railroad greatly increased the beach's popularity among inlanders seeking relief from the summer heat. In years prior, vacationers would drive down in wagons and camp along the beach, the best spots costing $8 per month.

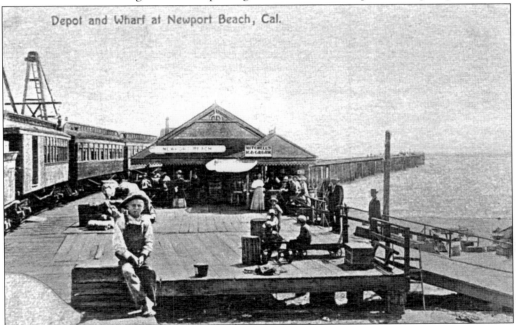

DEPOT AND WHARF AT NEWPORT BEACH, C. 1909. The Southern Pacific purchased the pier and railway with the intention of killing the shipping industry in Newport. By raising wharfage rates to a prohibitive figure, they forced lumber cargoes to go elsewhere. In January 1907, the last commercial shipment to pass over the pier was from Australia.

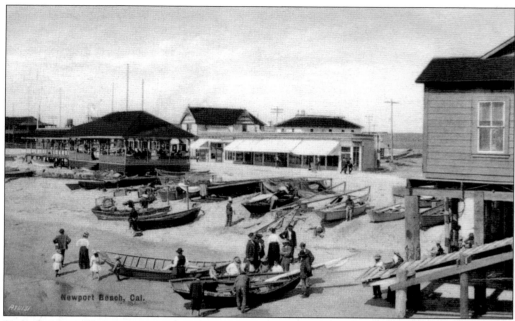

THE PARKER BLOCK AND SHARPS HOTEL, C. 1908. The Parker Block (center) housed a grocery store operated by Conrad Crookshank. Behind it is Newport's first hotel. Mrs. May Sharps dismantled the structure at San Juan-by-the-Sea (later to be called San Juan Capistrano) in 1892 and had it hauled to Newport, where it was reassembled. In 1910, it burned down.

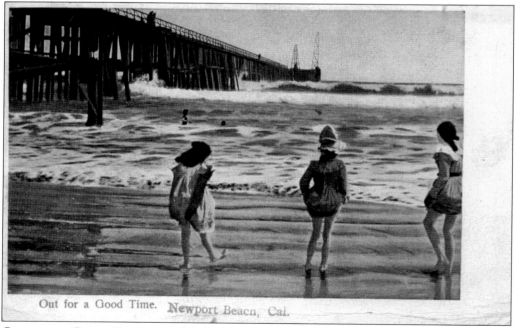

Out for a Good Time. Newport Beach, Cal.

OUT FOR A GOOD TIME, C. 1903. Early swimmers had to proceed cautiously. It would be a number of years before lifeguards came on the scene.

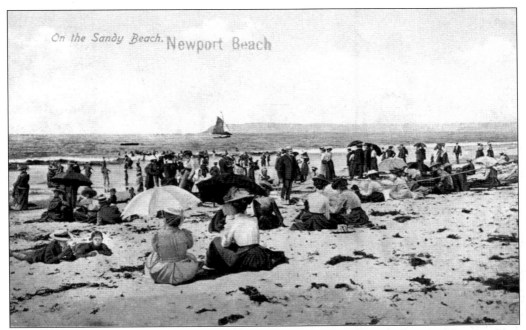

ON THE SANDY BEACH, C. 1909. Catalina Island, another popular spot for vacationers seeking a milder climate, is visible in the distance.

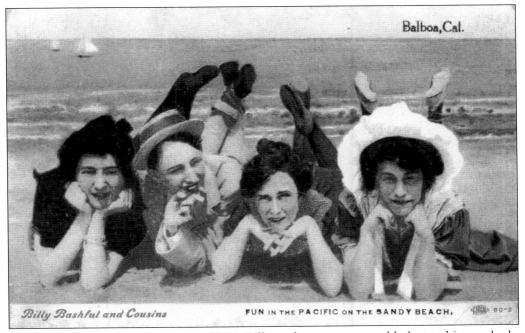

BILLY BASHFUL AND COUSINS, C. 1907. Billy, a character presumably lost to history, looks less than bashful in this playful early pose.

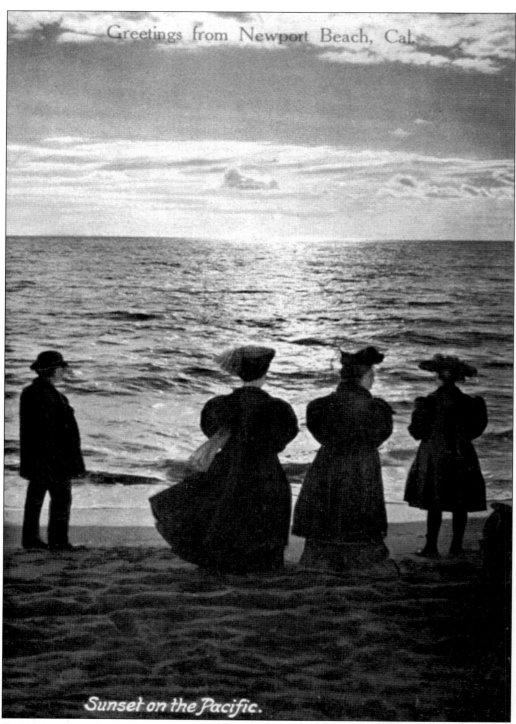

Greetings from Newport Beach, Cal.

Sunset on the Pacific.

SUNSET ON THE PACIFIC, C. 1907. The setting sun in Newport never fails to attract an audience of admirers.

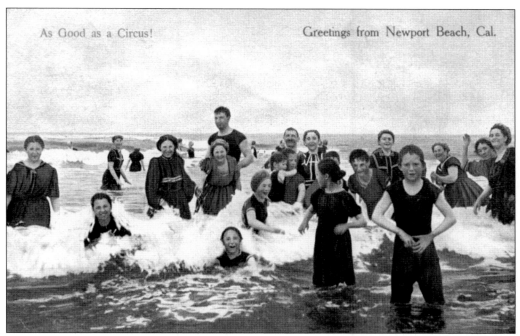

As Good as a Circus!

Greetings from Newport Beach, Cal.

As Good as a Circus! Victorian morals demanded that bathing attire resemble everyday clothing, as seen in this *c.* 1909 photograph.

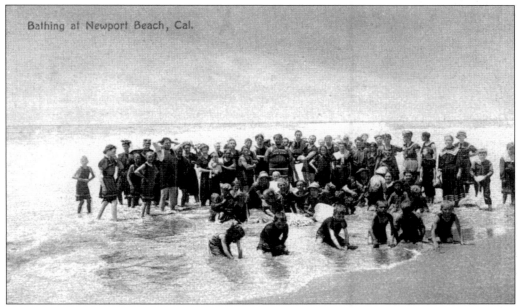

Bathing at Newport Beach, Cal.

Bathing at Newport Beach, *c.* 1908. Bathers could rent bathing togs at bathhouses in both Newport and Balboa.

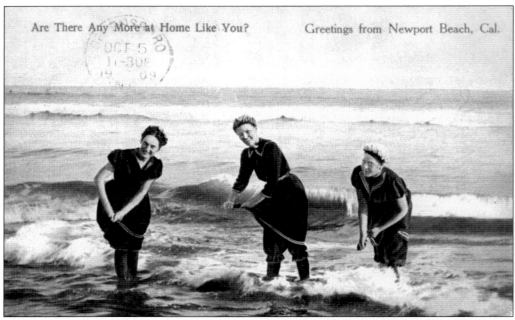

Are There Any More at Home Like You? Greetings from Newport Beach, Cal.

ARE THERE ANY MORE AT HOME LIKE YOU?, *C.* **1909.** Today's bikinis and swim trunks have made the practice of wringing salt water from bathing suits a lost art.

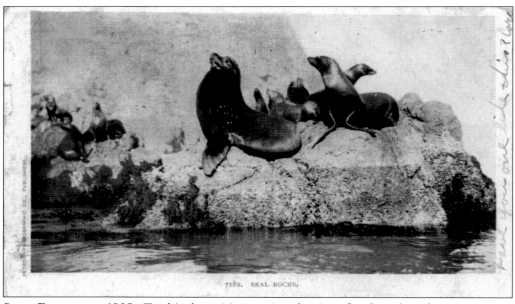

7182. SEAL ROCKS.

SEAL ROCKS, *C.* **1905.** To this day, visitors enjoy the site of seals and sea lions appearing from the depths alongside the Balboa Ferry or lounging on the buoy just beyond the mouth of the harbor.

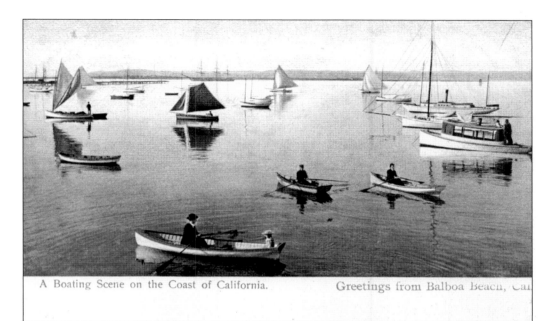

A Boating Scene on the Coast of California. Greetings from Balboa Beach, Cal

A BOATING SCENE ON THE COAST OF CALIFORNIA, *C.* **1906.** Add a few kayaks, and this scene is not so different from what one finds today beyond Newport's shore.

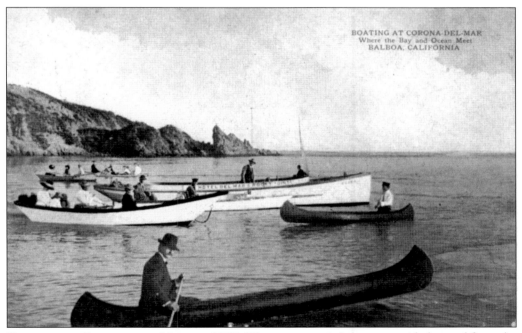

BOATING AT CORONA-DEL-MAR
Where the Bay and Ocean Meet
BALBOA, CALIFORNIA

BOATING AT CORONA DEL MAR, *C.* **1907.** Water transportation was provided to and from the Hotel del Mar, which perched on the bluffs of Corona del Mar, 90 feet above the bay. The center boat pictured here is from the hotel, which is just beyond the left edge of this postcard.

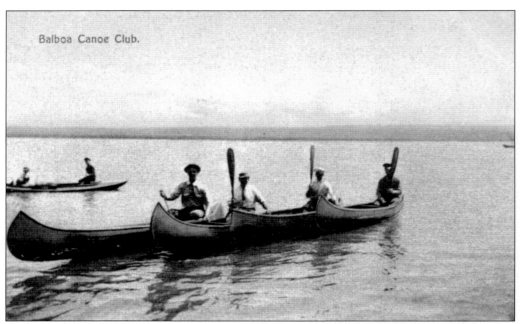

Balboa Canoe Club.

BALBOA CANOE CLUB, c. 1908. The Balboa Canoe Club, established in 1908, nominated Fred Beckwith as its first president. Beckwith was one of 16 "harbor boosters" who, in 1907, organized the chamber of commerce and pledged to the creation of a deep, navigable harbor.

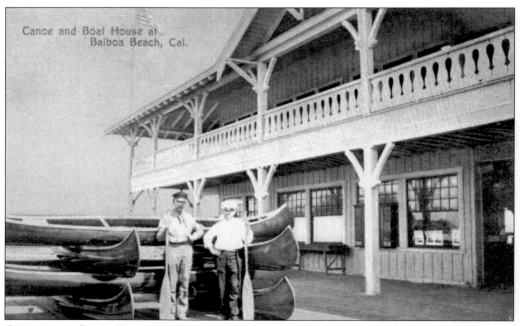

Canoe and Boat House at Balboa Beach, Cal.

CANOE AND BOAT HOUSE AT BALBOA BEACH, c. 1908. In its early years, Newport Harbor was filled with shallow lagoons, sandbars, and mudflats. The shallow draft of a canoe made it a safe mode of transport. By 1911, the harbor was home to some 200 rowboats and canoes.

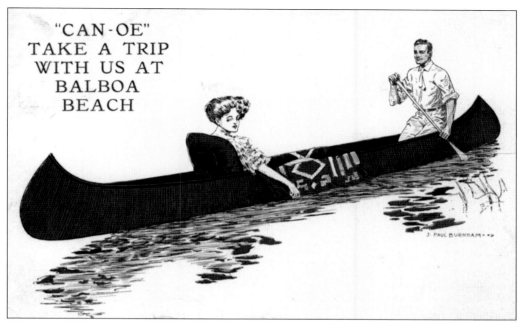

"CAN-OE" TAKE A TRIP WITH US, BALBOA BEACH, C. 1909. This card was sent by Fred Beckwith to a fellow canoer in Pasadena.

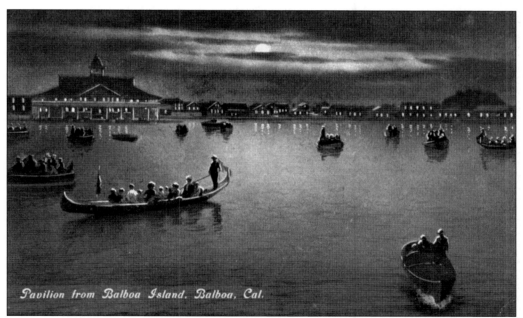

PAVILION FROM BALBOA ISLAND, BALBOA, C. 1909. In 1908, Venetian gondolier John Scarpa moved his gondolier business from Venice, California, to Newport Bay. For several years, he took visitors and dignitaries around the harbor, serenading them in true Venetian style.

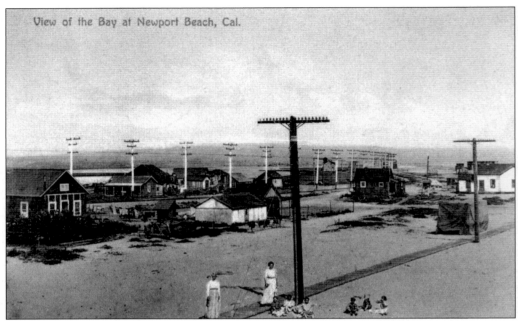

View of the Bay at Newport Beach, Cal.

VIEW OF THE BAY AT NEWPORT BEACH, C. 1909. On February 18, 1909, C. H. Ghreist requested permission from the board of trustees to erect power poles in the streets of the city. On March 1, his request was granted, and the Newport Bay Electric Light and Power Company began supplying electricity to the citizens of Newport.

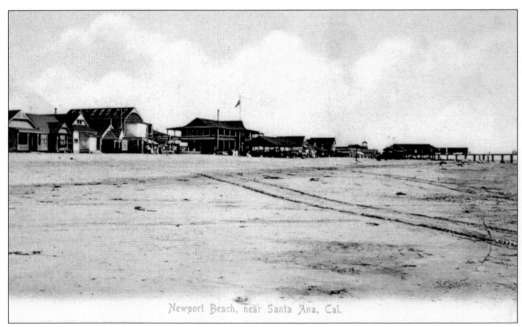

Newport Beach, near Santa Ana, Cal.

NEWPORT BEACH, NEAR SANTA ANA, C. 1909. The Newport Hotel is visible at center, and the El Verano store is to its left. Note the train leaving the pier on the right.

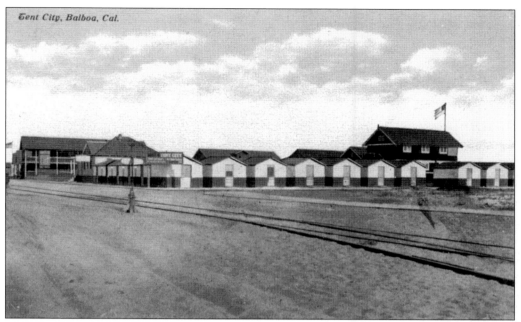

TENT CITY, BALBOA, *C.* **1909.** When the Balboa Hotel failed to provide sufficient accommodations, pioneer realtor Everett Chase established a tent city annex on the east side of Main Street, between Balboa Boulevard and the ocean.

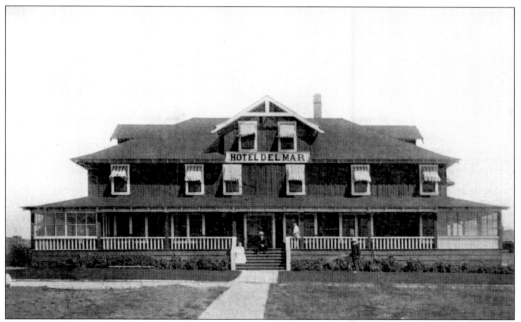

HOTEL DEL MAR, *C.* **1908.** In 1904, George E. Hart purchased the Corona del Mar section from James Irvine. The following year, work began on the 30-room Hotel del Mar, which opened its doors on July 20, 1907. The building had closets, toilets, a bathroom on each floor, gas lighting, fireplaces, and a ladies' parlor. Verandas circled the hotel on three sides, allowing views of the ocean, bay, and hills for diners eating on the screened porches.

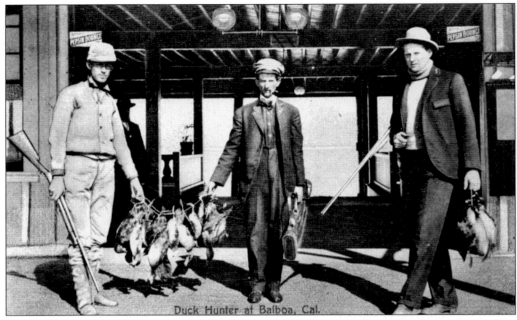

Duck Hunter at Balboa, Cal.

DUCK HUNTER AT BALBOA, C. 1908. Prior to 1900, Newport Bay was a hunter's paradise; the majority of visitors to Newport Bay were lured by excellent duck hunting.

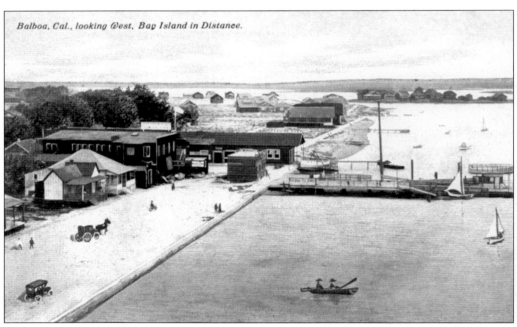

Balboa, Cal., looking West, Bay Island in Distance.

BALBOA, LOOKING WEST, BAY ISLAND IN DISTANCE, C. 1908. In the 1890s, Edward J. Abbott brought soil from the mainland for planting these first trees on the peninsula (left). The Abbotts planted palms, Monterey cypress, and eucalyptus trees.

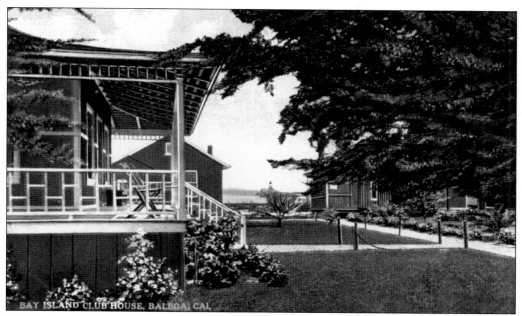

BAY ISLAND CLUB HOUSE, BALBOA, C. 1909. Bay Island was originally a small knoll surrounded by overflow lands and reached by a long plank trestle extending from the present location of Bay Avenue. Dredging began in 1909, and in 1910, the footbridge to the island was built. By 1930, there were 23 homes on the small island. The clubhouse was removed that same year. Note the pavilion in the distant background.

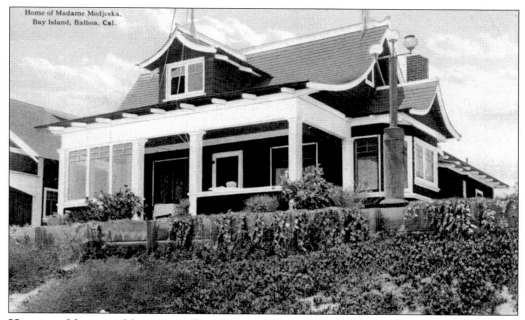

HOME OF MADAME MODJESKA, BAY ISLAND, BALBOA, C. 1909. In 1908, Helena Modjeska, the great Polish actress, bought this pagoda-style house at 3 Bay Island. She died the following year. In 1941, the house was replaced.

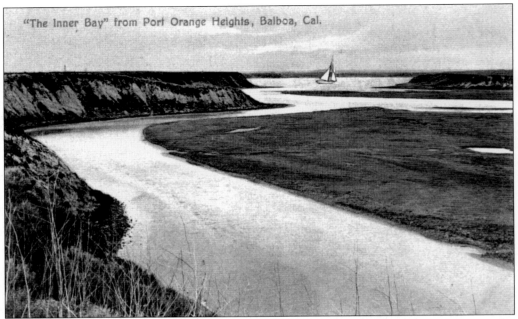

"The Inner Bay" from Port Orange Heights, Balboa, Cal.

THE INNER BAY FROM PORT ORANGE HEIGHTS, BALBOA, C. 1907. Port Orange, also known as McFadden's Landing, was comprised of a dock and small warehouse, built by D. M. Dorman and Captain Dunnels. In 1873, it was purchased by the McFaddens to support their burgeoning lumber company.

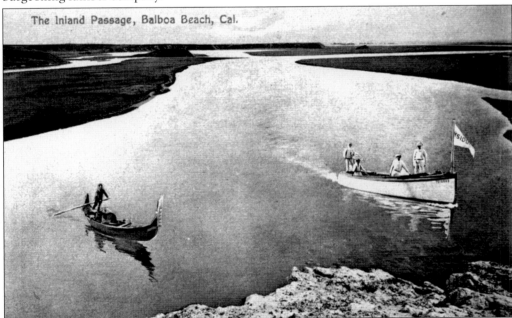

The Inland Passage, Balboa Beach, Cal.

THE INLAND PASSAGE, BALBOA BEACH, C. 1907. The upper Newport Bay is an estuary, a place where fresh and saltwater meet and mix. As one of the few remaining estuaries in Southern California, it is home to nearly 200 species of birds, including several endangered species. During the winter, as many as 30,000 birds can be seen here on any given day.

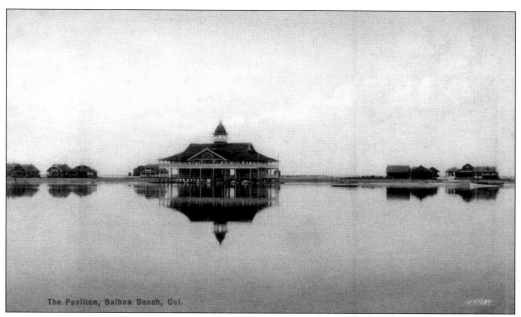

The Pavilion, Balboa Beach, Cal.

THE PAVILION, BALBOA BEACH, C. 1907. In the spring of 1905, the Balboa Pavilion was built by Chris MacNeil for the Newport Bay Investment Company. Lumber for the structure was barged in, as neither a railway nor a wagon road to Balboa existed at the time.

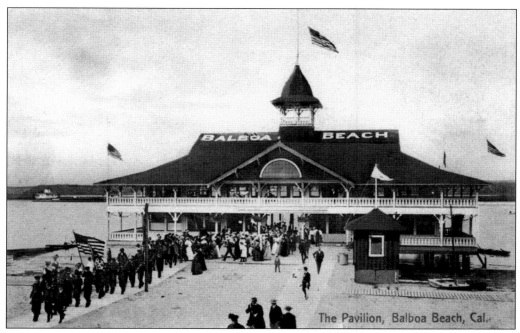

The Pavilion, Balboa Beach, Cal.

PAVILION AT BALBOA BEACH, C. 1907. On July 4, 1906, the Pacific Electric ran their first train to Balboa, where a giant barbecue welcomed the passengers. Nearly 1,000 beachgoers took the one-hour ride from Los Angeles that day, mostly from Pasadena.

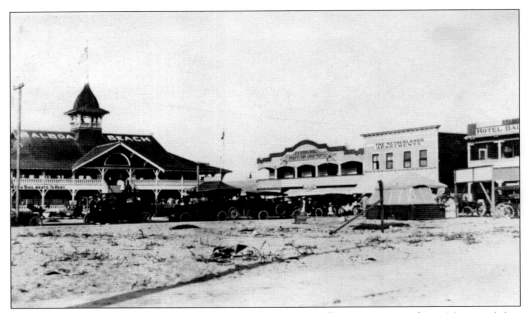

MAIN STREET, BALBOA BEACH, C. 1909. In a last minute effort to accommodate visitors arriving on the Pacific Electric, the 15-room Balboa Hotel, on the far right, was built in 10 days.

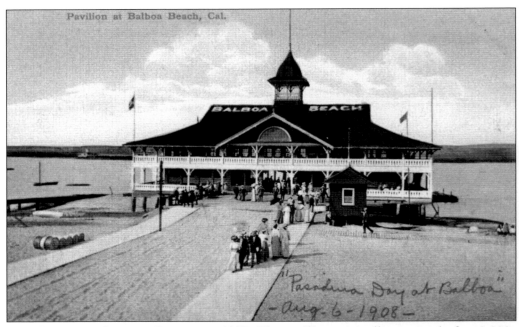

THE PAVILION, BALBOA BEACH, C. 1907. The pavilion originally consisted of an 8,000-square-foot meeting room on the second story and a simple bathhouse on the first floor, where people could change from street attire into bathing suits.

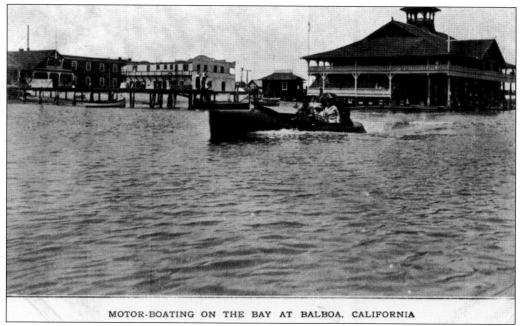

MOTOR-BOATING ON THE BAY AT BALBOA, CALIFORNIA

MOTORBOATING ON THE BAY AT BALBOA, C. 1909. One of the early businesses within the pavilion was a ping pong stand, opened by Soto Nishikawa in 1907. In later years, he would open a chop suey shop and novelty store in other locations. One of the most loved men in Balboa, Soto was sent to a Japanese internment camp during World War II and never returned to Newport.

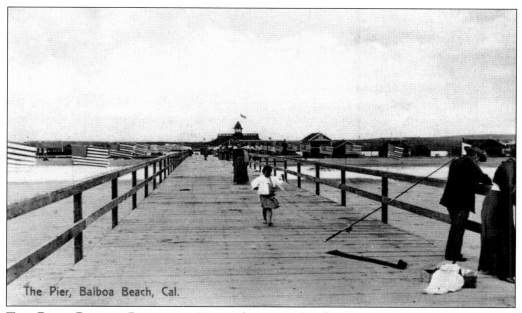

The Pier, Balboa Beach, Cal.

THE PIER, BALBOA BEACH, C. 1908. The original Balboa Pier was constructed in 1905, concurrent with the pavilion, as an added attraction for visitors taking the train down from Los Angeles.

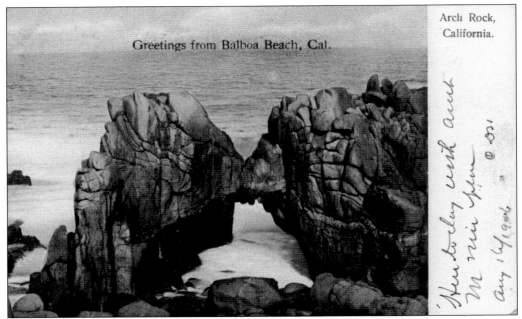

Greetings from Balboa Beach, Cal.

Arch Rock, California.

ARCH ROCK, C. 1906. The famous Arch Rock, subject of numerous early postcards, resides a short distance off the shore of Corona del Mar.

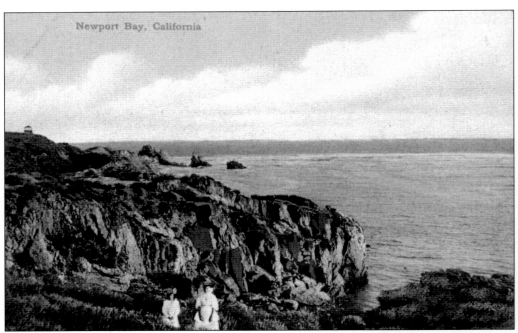

Newport Bay, California

THE PICNIC GROUNDS, CORONA DEL MAR, C. 1906. Visitors could board a launch at the Balboa Pavilion to Corona del Mar. Those with the energy to ascend the bluffs were rewarded with a marvelous view of the ocean and harbor.

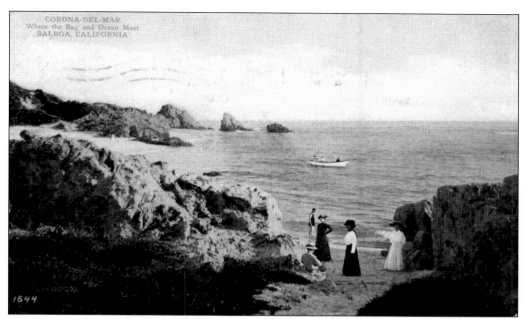

WHERE THE BAY AND THE OCEAN MEET, C. 1906. Prior to the building of the upper bay bridge in 1926, visitors to Newport had only two ways to reach Corona del Mar. They could boat across the harbor or take the long journey around the back bay.

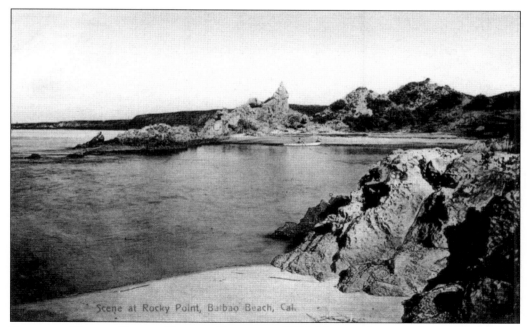

SCENE AT ROCKY POINT, BALBOA BEACH, C. 1907. Newport's more adventurous visitors might row to Rocky Point, where gathering abalone was a popular activity.

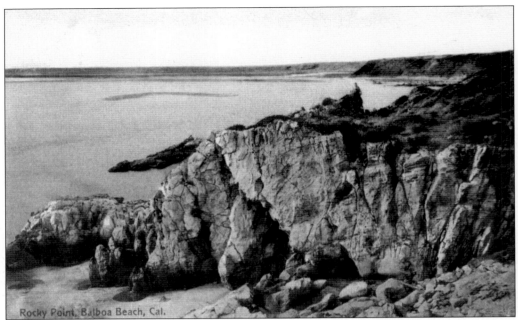

ROCKY POINT, BALBOA BEACH, *C.* **1908.** Needing funds for ranch improvements, James Irvine sold 700 acres on the bluffs behind Rocky Point to George E. Hart for $150 per acre in 1904. The acreage was subdivided into lots, but by 1915, only 15 houses and a small hotel had been built. Discouraged, Hart traded 400 of the 700 acres for land in Riverside County valued at $400,000.

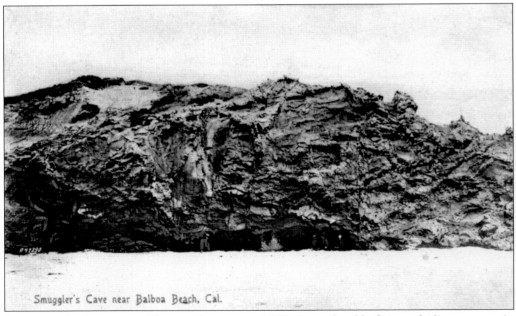

SMUGGLER'S CAVE NEAR BALBOA BEACH, *C.* **1908.** Legends told of pirates hiding treasure in the caves of Corona del Mar, making their exploration another popular attraction.

Two

THE 1910S

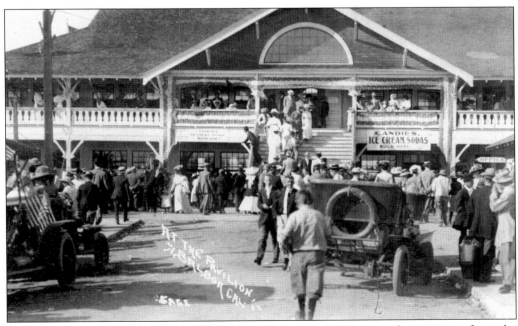

AT THE PAVILION, BALBOA, C. 1914. Mary Harlan, born just seven houses away from the pavilion in June 1909, recalled in 1981 that the balcony was the place to be on Friday nights when throngs gathered for fun.

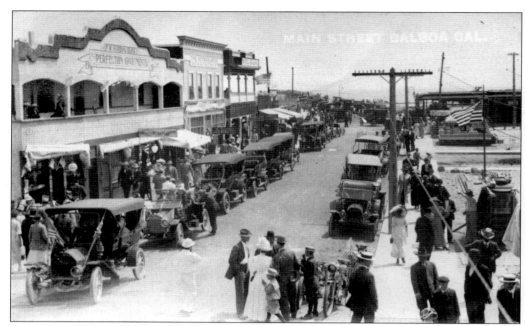

Main Street, c. 1912. In 1911, the Netherlands Apartments (middle left) were built in East Newport by John Meurs. Deciding Balboa would be a better location for the structure, he moved it to Main Street in 1912. Note the Pacific Electric red car in the background on the far right and the pier in the distance.

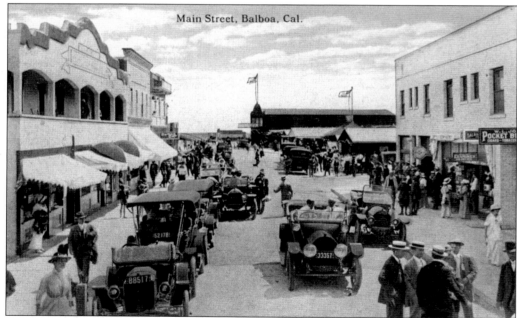

Main Street, Balboa, c. 1915. Looking up Main Street from the pavilion, beneath the flagpole at the pier, is the Balboa Theatre, built in 1913. In 1916, Mrs. W. A. Osgood, better known by her theatrical name of Madame LaRue, managed the theatre until it closed in 1928, the same year the Ritz theatre opened around the corner.

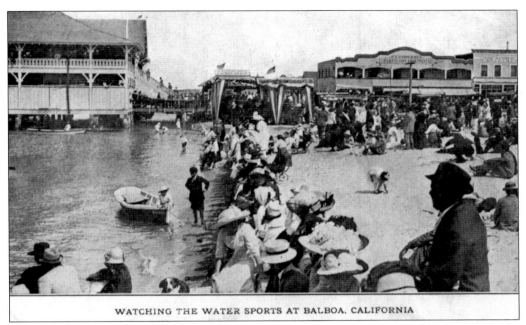

WATCHING THE WATER SPORTS AT BALBOA, CALIFORNIA

WATCHING THE WATER SPORTS AT BALBOA, C. 1912. In 1910, F. W. Harding built the Perfection Apartments (top right).

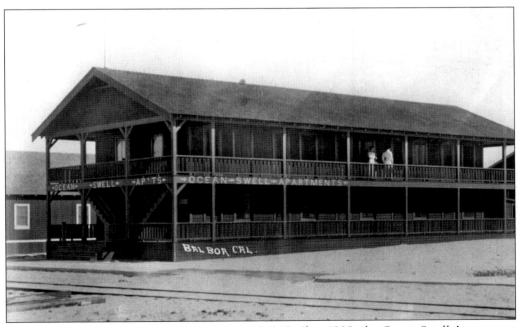

OCEAN SWELL APARTMENTS, BALBOA, C. 1911. Built *c.* 1908, the Ocean Swell Apartments stood at the present corner of Balboa Boulevard and A Street.

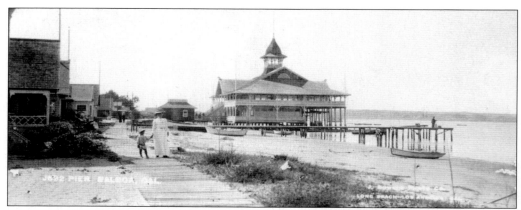

BAYSIDE BOARDWALK, BALBOA, *C.* 1915. While a boardwalk exits on the bay side, west of the pavilion, this portion east of the structure is but a memory.

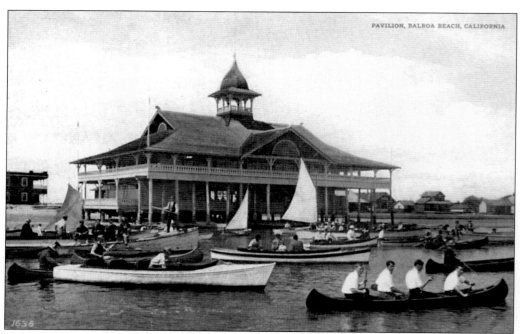

PAVILION, BALBOA BEACH, *C.* 1910. The pavilion has been home to many ventures over its history, including restaurants, sports fishing, offices, an art museum, gambling parlors, and bowling alleys.

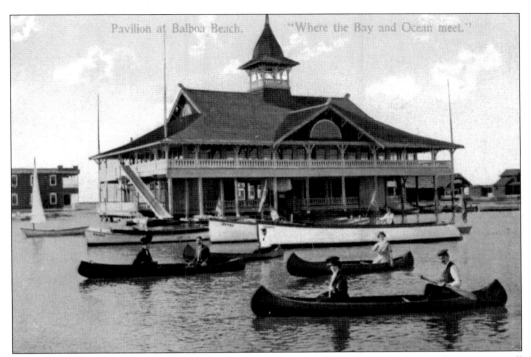

PAVILION AT BALBOA BEACH, C. 1911. At Balboa Beach, "where the bay and ocean meet," canoeing was a popular sport, enjoyed by both men and women.

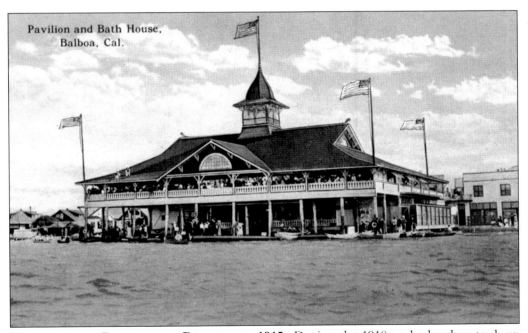

PAVILION AND BATHHOUSE, BALBOA, C. 1915. During the 1910s, a barbershop took up residence in the pavilion. It employed an infamous barber called "Lucky Tiger Jack," so named because of his propensity to indulge heavily in his Lucky Tiger hair tonic.

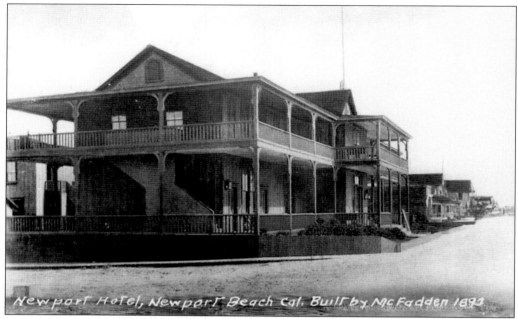

Newport Hotel, Newport Beach Cal. Built by McFadden 1893

NEWPORT HOTEL, NEWPORT BEACH, C. 1912. Only open during the summer months, the Newport Hotel, built by McFadden in 1893, entertained fashionable guests who enjoyed its large dining room. Visiting sea captains also favored the hotel, located west of the pier on the oceanfront. In April 1925, it sold at an auction (to be wrecked) at a cost of $400.

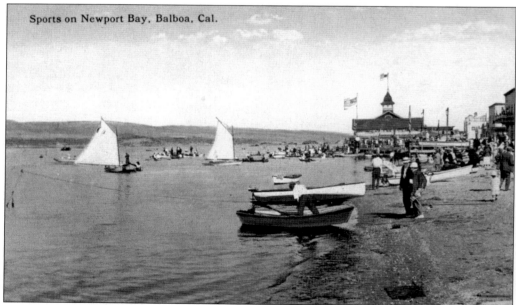

Sports on Newport Bay, Balboa, Cal.

SPORTS ON NEWPORT BAY, BALBOA, C. 1916. The bay has always been a popular spot for boaters and fishermen, as well as tourists simply looking for a tranquil spot to sit and take in the sights and sounds of Newport.

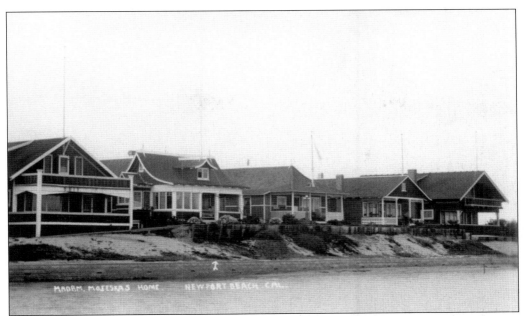

MADAME MODJESKA'S HOME, BAY ISLAND, *C.* 1911. When Madame Modjeska passed away on April 18, 1909, the Pacific Electric sent a large, black, private railroad car to East Newport to meet the procession carrying her coffin across the small, white, wooden bridge from Bay Island. Her death and funeral resulted in much publicity, both national and international, for Newport Beach.

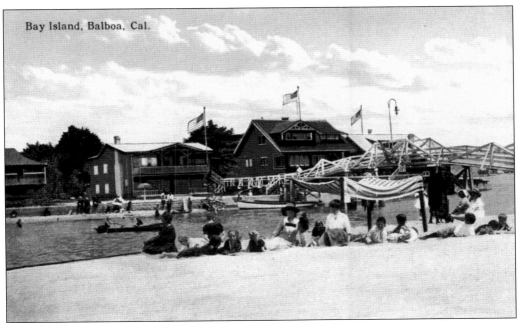

BAY ISLAND, BALBOA, *C.* 1916. Until 1931, the footbridge to Bay Island, built in 1910, was affectionately known as "the little white bridge." After a periodical overhauling of the structure, it was renamed "the little blue bridge."

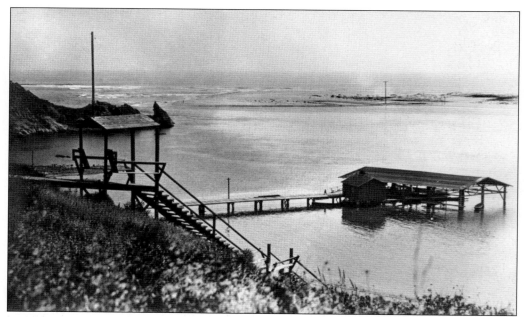

HOTEL DEL MAR FERRY LANDING, C. 1911. The harbor entrance and the east end of the peninsula are seen in this photograph. The pole near the top right marks the approximate corner of Granada and M Streets.

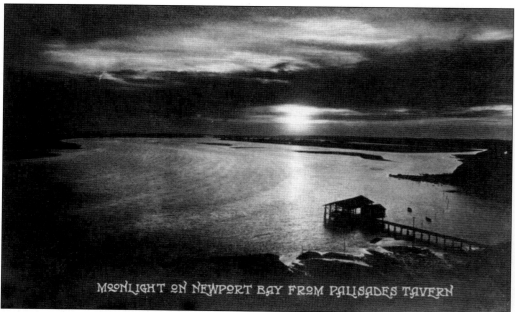

MOONLIGHT ON NEWPORT BAY FROM PALISADES TAVERN

MOONLIGHT ON NEWPORT BAY FROM PALISADES TAVERN, C. 1915. In 1915, George E. Hart traded 400 of the 700 acres he had purchased from the Irvine Ranch to the F. D. Cornell Company. The new owners remodeled the Hotel del Mar and reopened it under the name Balboa Palisades Tavern. The Cornell Company attempted to change the name of the Corona del Mar section to Balboa Palisades, but the new name never took hold.

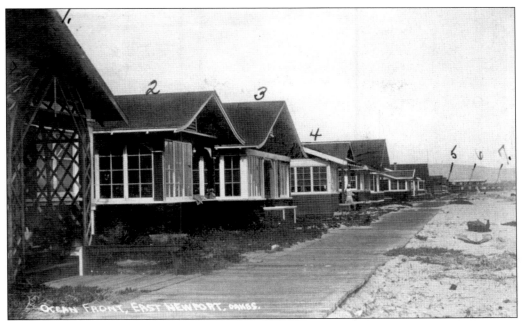

OCEAN FRONT, EAST NEWPORT, C. 1911. The ocean front in East Newport included the following: Stanley Castlewans's cottage (1); Mrs. Lindenberger's cottage (2); the Daniels' cottage (3); the Abbott cottage, with Doris out on the steps (4); the Evans' cottage (5); apartment house between East Newport and Balboa (6); and Balboa and the hills over at Corona del Mar (7).

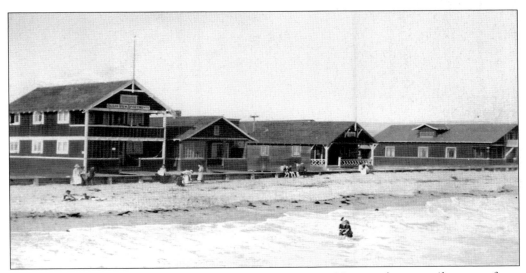

ON THE BEACH, BALBOA, C. 1919. Swimmers rest on Newport's two-mile, oceanfront boardwalk. Constructed in 1917 and 1918, it was the promenade between the villages of Newport and Balboa. In 1936, a concrete sidewalk replaced the deteriorating wooden boards.

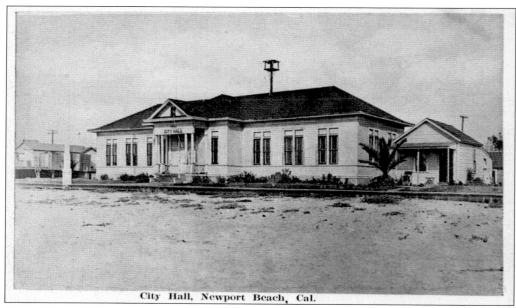

City Hall, Newport Beach, Cal.

CITY HALL, NEWPORT BEACH, C. 1918. Previously a schoolhouse, this building was rented by the city in 1912 for $200 per month to be used as a city hall, before finally being purchased in December of that same year. The west room was loaned to the Methodist Church for Sunday services.

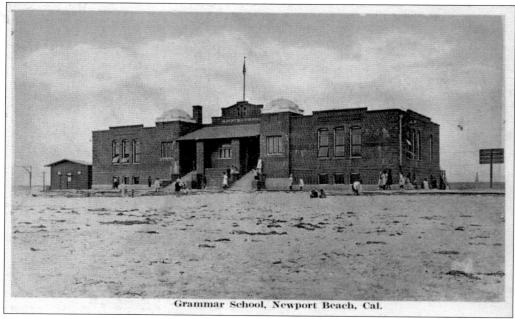

Grammar School, Newport Beach, Cal.

GRAMMAR SCHOOL, NEWPORT BEACH, C. 1918. On March 9, 1912, the school district approved $27,000 for the construction of a new school, which is the easterly half of the present structure between Thirteenth and Fourteenth Streets. The building contained four classrooms, an auditorium, a principal's office, a small library, and two rooms in the basement. In 1922, the school had outgrown its facilities and expanded to take up the whole block.

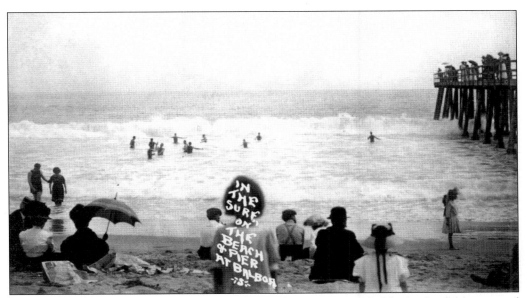

IN THE SURF, ON THE BEACH, AND PIER AT BALBOA, C. 1911. The back of this postcard reads, "Don't you wish you were here? I'm sitting on the sand drying my hair, as I have just been doing what you see these people doing."

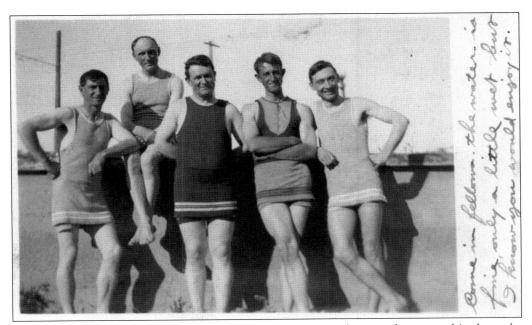

FIVE FRIENDS, NEWPORT BEACH, C. 1911. Enterprising photographers were hired to take pictures and fashion them into postcards to send to the folks back home.

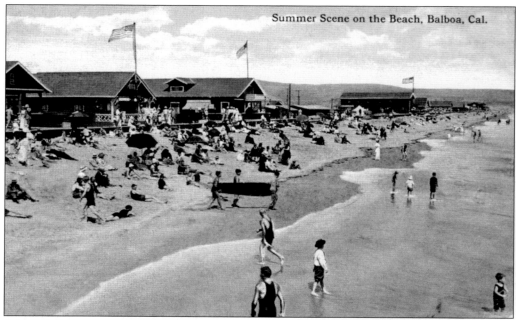

Summer Scene on the Beach, Balboa, Cal.

SUMMER SCENE ON THE BEACH, BALBOA, C. 1915. In 1936, the narrow peninsula and beach, shown here, were considerably widened by a Works Progress Administration (WPA) project.

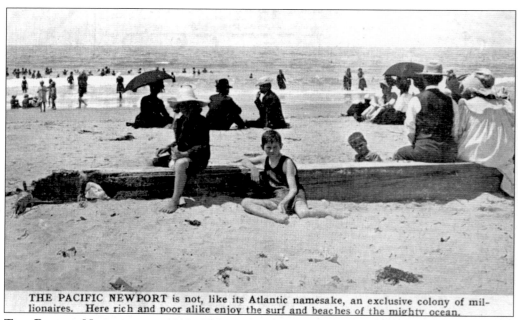

THE PACIFIC NEWPORT is not, like its Atlantic namesake, an exclusive colony of millionaires. Here rich and poor alike enjoy the surf and beaches of the mighty ocean.

THE PACIFIC NEWPORT, C. 1912. This card was produced by the Southern Pacific Railroad as part of an ad campaign to encourage people nationwide to come to Newport. "The Southern Pacific is offering special low rates from March 1 to April 15, 1912, in order that you may see our glorious western country. Why put off the trip any longer?"

44

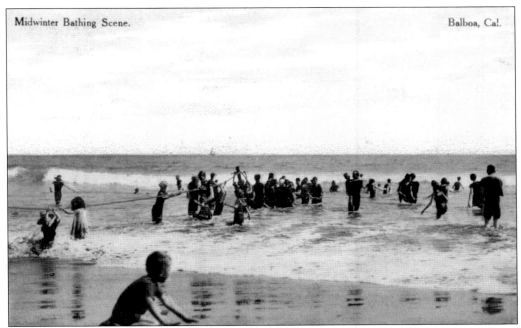

Midwinter Bathing Scene. Balboa, Cal.

MIDWINTER BATHING SCENE, BALBOA, C. 1910. There were no lifeguards in the early days, but a lifeline through the breakers offered security to bathers, many of whom could not swim.

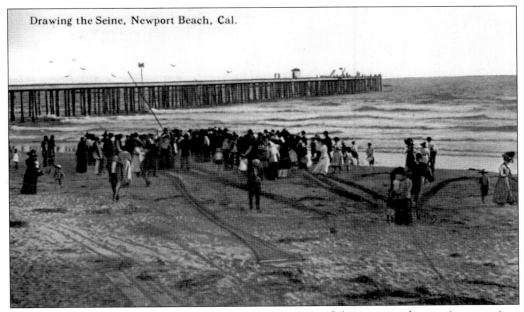

Drawing the Seine, Newport Beach, Cal.

DRAWING THE SEINE, NEWPORT BEACH, C. 1913. Seine fishing, a popular tourist attraction, involved horses drawing smelt-filled nets onto the shore.

45

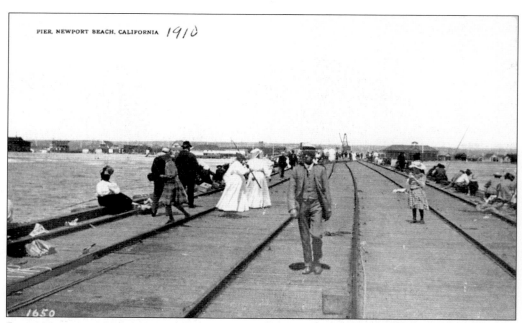

PIER, NEWPORT BEACH, CALIFORNIA 1910

1650

PIER, NEWPORT BEACH, 1910. Fishermen and strollers were able to enjoy the pier on Sundays as "nary a wheel turned on the railroad that day."

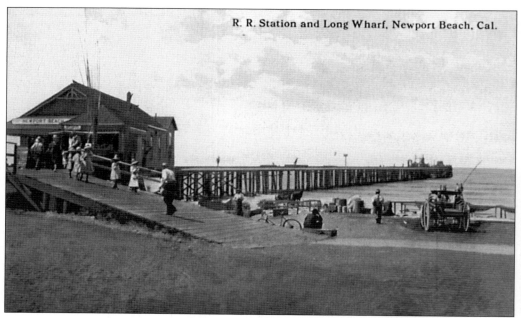

R. R. Station and Long Wharf, Newport Beach, Cal.

RAILROAD STATION AND LONG WHARF, NEWPORT BEACH, C. 1913. These five girls have discovered Dragon Ice Cream, served at the railroad station.

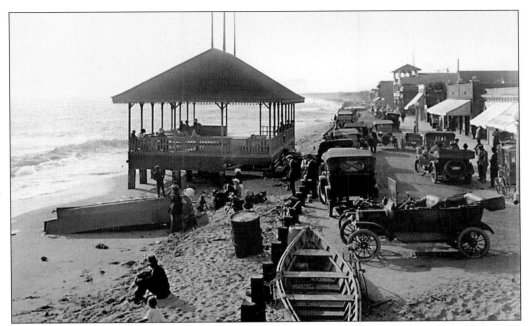

WEST OF THE NEWPORT PIER, C. 1914. The Newport Pavilion, or Ocean Front Pavilion, was a great spot for a picnic during the day, or dancing on a Saturday evening.

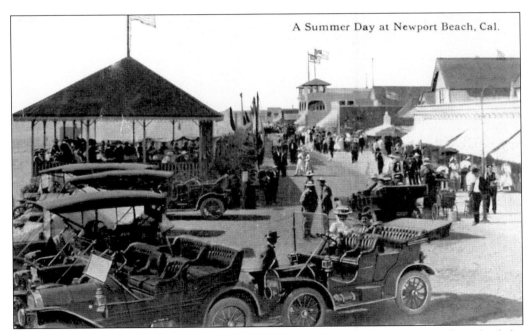

A Summer Day at Newport Beach, Cal.

A SUMMER DAY AT NEWPORT BEACH, C. 1913. In 1920, the Newport Pavilion, built by Stephen Townsend, burned down.

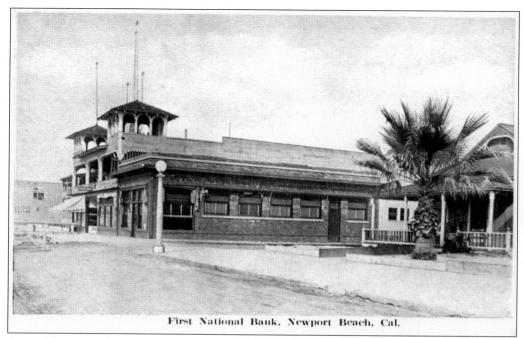

First National Bank, Newport Beach, Cal.

FIRST NATIONAL BANK, NEWPORT BEACH, C. 1918. The First National Bank was erected in 1913 to replace the State Bank of Newport, which was heavily damaged with explosives used by three bungling burglars in June of the previous year. The trio managed to escape but left most of the money behind.

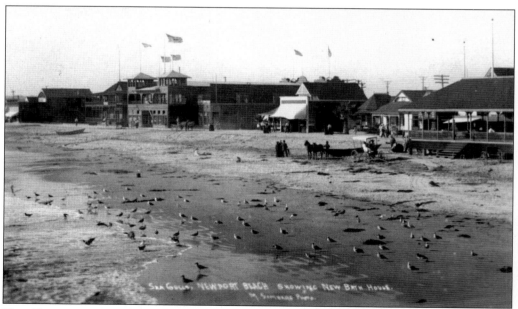

NEW BATHHOUSE, NEWPORT BEACH, C. 1911. Visitors could rent dressing rooms and bathing suits for the day in the new bathhouse (left of center), built west of the Newport Pier.

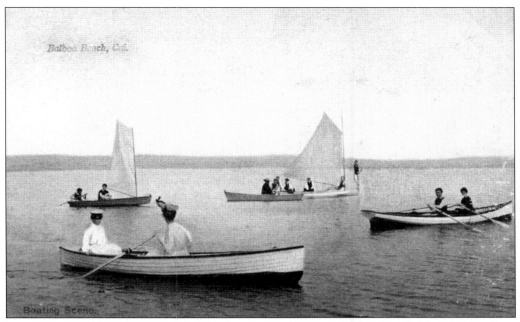

BALBOA BEACH, C. 1912. Balboa Beach was called by many "the place for fine boating"—a sentiment as true today as it was a century ago.

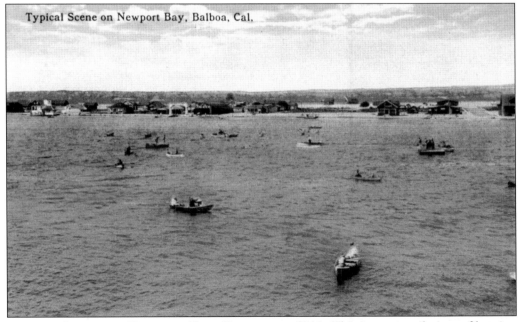

TYPICAL SCENE ON NEWPORT BAY, BALBOA, C. 1915. This is a tranquil view of boating on the bay, with Balboa Island in the distance. Note the theatre (left of center) and the white arch in front of it.

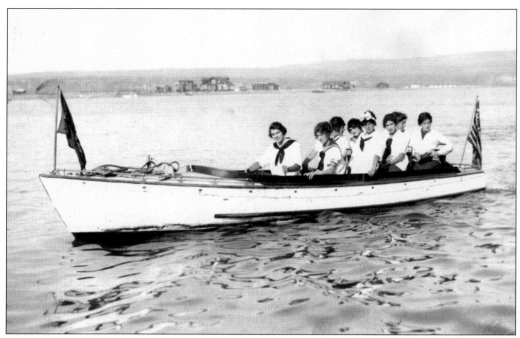

BOATING, BALBOA, C. 1915. A women's group aboard the *Rowena* steers west, parallel to the peninsula.

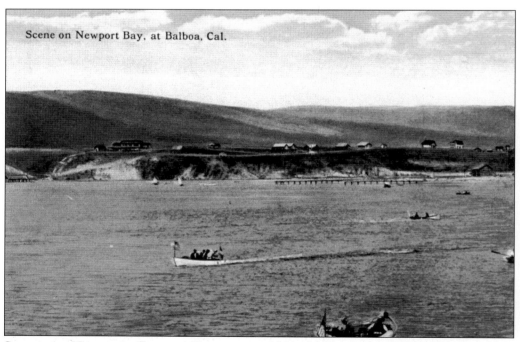

Scene on Newport Bay, at Balboa, Cal.

SCENE ON NEWPORT BAY, AT BALBOA, C. 1913. Although Corona del Mar had been subdivided in 1904, few houses had been built by the time this photograph was taken almost a decade later.

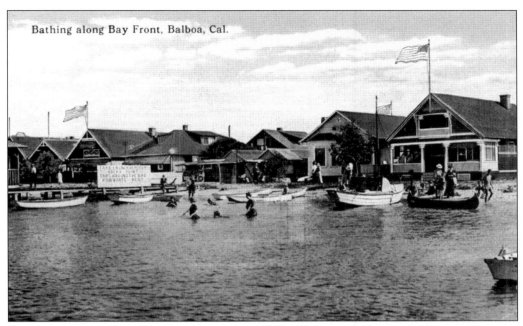

BATHING ALONG BAY FRONT, BALBOA, c. 1915. Visitors to this popular spot could hire a launch to take them around the bay or to Rocky Point in Corona del Mar.

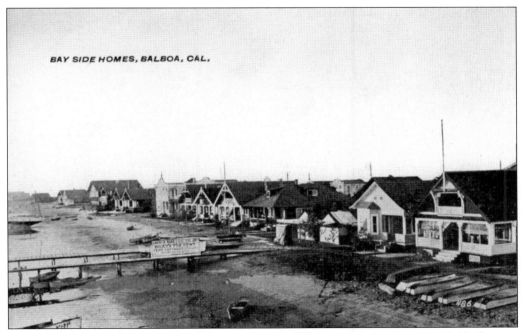

BAY SIDE HOMES, BALBOA, c. 1918. For a nominal fee, tent cottages were available for rent right on the bay.

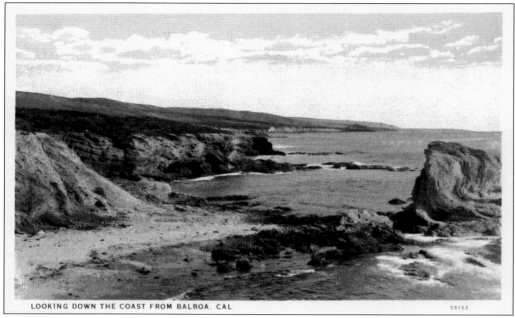

LOOKING DOWN THE COAST FROM BALBOA, CAL.

55153

LOOKING DOWN THE COAST FROM BALBOA, C. 1915. Almost a century of development would offer a far different view from this vantage point today.

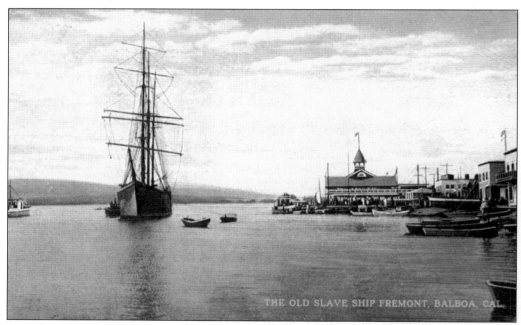

THE OLD SLAVE SHIP FREMONT, BALBOA, CAL.

THE OLD SLAVE SHIP *FREMONT*, BALBOA, C. 1919. Returning from a day of motion picture work at sea, the *Fremont* wrecked on the sandbar at the harbor entrance. The following Sunday, the ship, built in Philadelphia in 1852, was dynamited. A number of stock movie shots were made of the wreck, which appeared in films over the next several years.

Three

THE 1920S

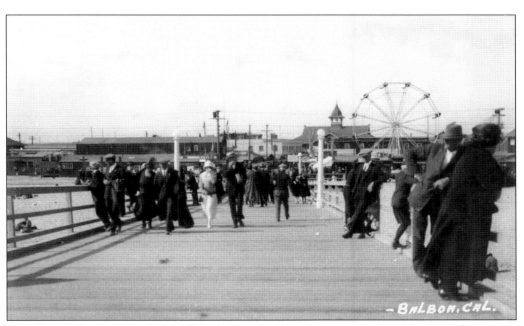

THE PIER, BALBOA, C. 1924. Years before the Fun Zone appeared on the bay side, visitors enjoyed a Ferris wheel on the ocean side of the peninsula.

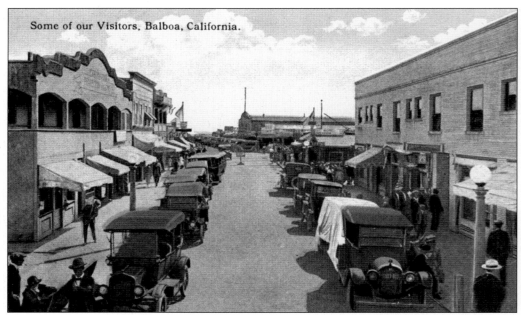

SOME OF OUR VISITORS, BALBOA, C. 1921. In 1913, the Knight Apartments, on the right, were built by Frank J. Knight. The building still stands today.

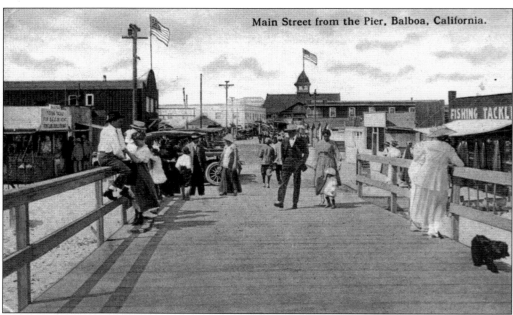

MAIN STREET FROM THE PIER, BALBOA, C. 1921. On June 7, 1921, a bond issue for the sum of $25,000 for a new Balboa Pier was carried by a vote of 155 to 41. The William Ledbettor Company won the contract. Initial plans overlooked a lighting system, which was added later at an additional cost.

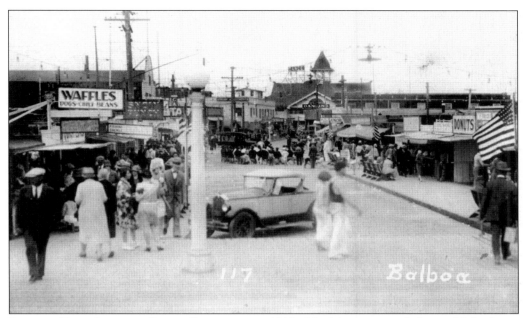

BALBOA PIER SUMMER BAND CONCERT, C. 1928. Musicians set up chairs on Main Street to play for a holiday crowd. A few years earlier, in 1923, the pavilion was remodeled to make it more suitable for dancing. Signs on the roof and facade read "Dance" and "Dancing," making it clear that this was the place to cut a rug.

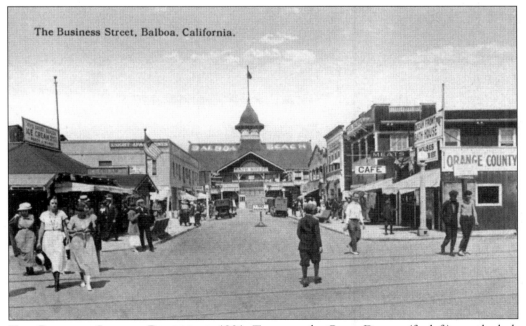

THE BUSINESS STREET, BALBOA, C. 1921. To many, the Green Dragon (far left) was the hub of the town, the social, cultural, and political center of activity. A popular destination for lunch, it was perhaps even more popular for the bootleg liquor served in its back booths.

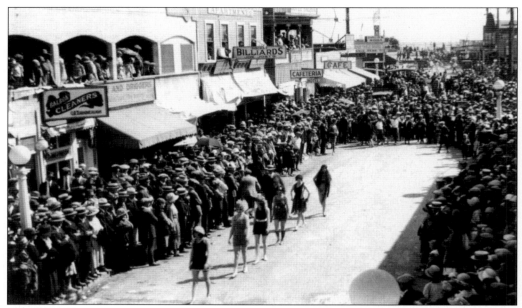

BATHING BEAUTIES ON MAIN STREET, C. 1924. Bathing beauty contests were part of day-long festivities arranged by the chamber of commerce and Madame LaRue Osgood to attract visitors to Balboa. Madame Osgood had to import girls for the annual beauty contest because local girls "would never be seen in those costumes."

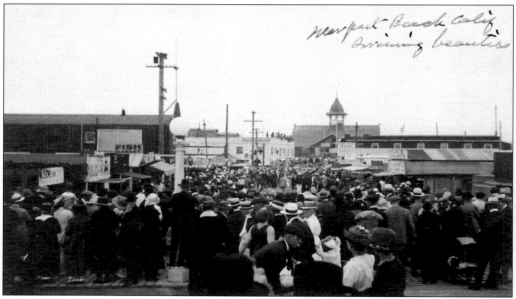

CROWDS AT THE BATHING BEAUTIES PARADE, C. 1924. The bathing beauties became one of Balboa's most popular attractions, bringing as many as 25,000 visitors to the village.

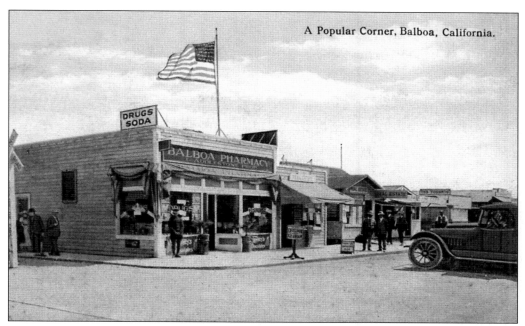

A POPULAR CORNER, BALBOA, C. 1921. The Balboa Pharmacy opened in 1920 on the southeast corner of Central Avenue and Main Street. Lewis Addlestone was the new druggist. Within two years, he sold the business to Walter Eastlack.

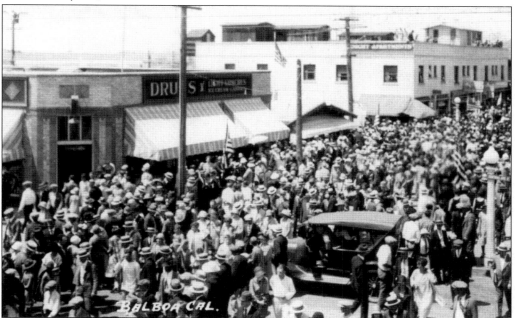

CROWDS ON MAIN STREET, BALBOA, C. 1924. In 1924, Eastlack opened Balboa Pharmacy No. 2 on the northwest corner of the same intersection in the newly completed Louis W. Briggs building. Since his lease on the first pharmacy ran another year, there were two pharmacies in Balboa for the 1924 season. In 1928, Eastlack sold Balboa Pharmacy No. 2 to Mickey Walker and Alfonse Hamann.

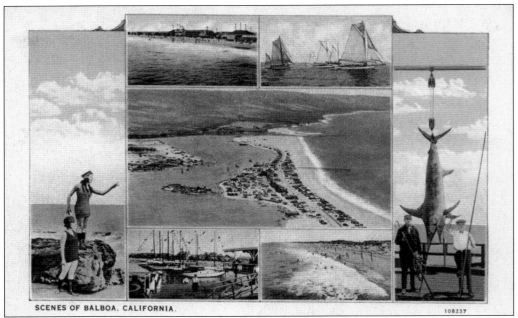

SCENES OF BALBOA, C. 1926. This card illustrates that for swimming, fishing, or sailing, Newport is the place to be.

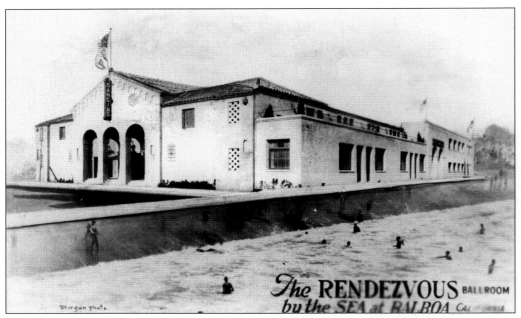

THE RENDEZVOUS BALLROOM, BY THE SEA AT BALBOA, C. 1928. Built in 1928 between Washington and Palm Streets on the oceanfront, the Rendezvous quickly became Southern California's premiere dance hall. By 1935, all the major headliners played the ballroom: Stan Kenton, the Dorsey Brothers, Harry James, Glenn Miller, and Benny Goodman. In 1966, the building succumbed to fire. Today a marker on the corner of Washington Street and Ocean Front Boulevard commemorates the site.

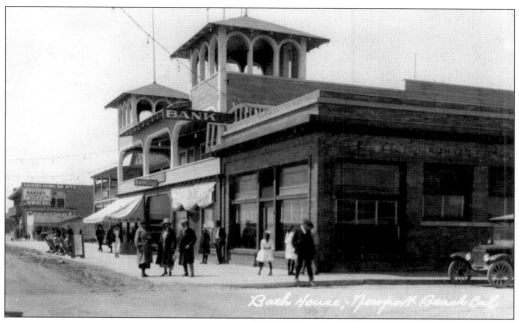

BATHHOUSE, NEWPORT BEACH, C. 1924. Here visitors could rent bathing suits and changing rooms during the day and come back in the evening to dance.

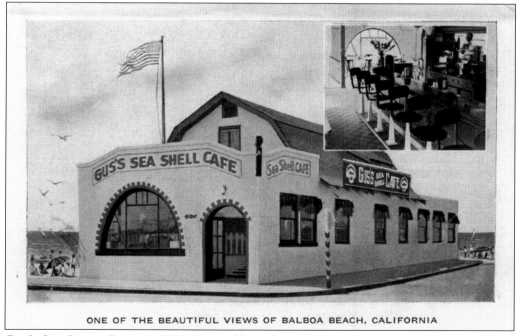

ONE OF THE BEAUTIFUL VIEWS OF BALBOA BEACH, CALIFORNIA

GUS'S SEA SHELL CAFE, C. 1925. Gus and his cafe are a distant memory now, but this building still stands on the corner of Palm Street and Balboa Boulevard.

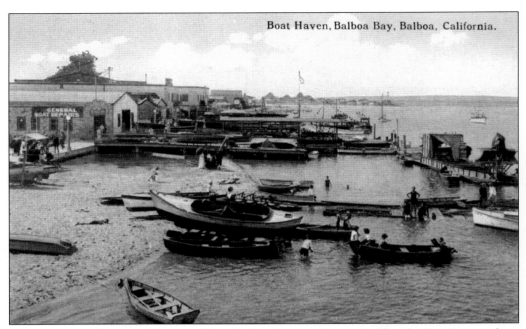

Boat Haven, Balboa Bay, Balboa, California.

BOAT HAVEN, BALBOA BAY, C. 1921. Today this spot is occupied by the Fun Zone, where boats of all kinds are still available for rent. Bay Island is visible in the distance.

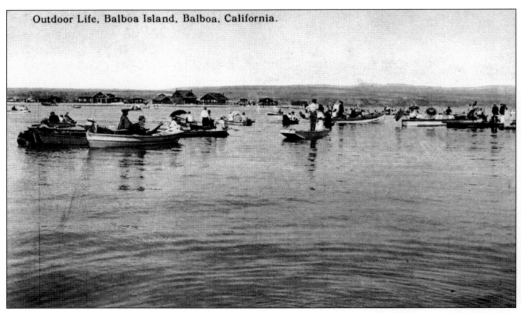

Outdoor Life, Balboa Island, Balboa, California.

OUTDOOR LIFE, BALBOA ISLAND, C. 1921. By the early 1920s, many houses dotted Balboa Island, but the hills beyond remained undeveloped.

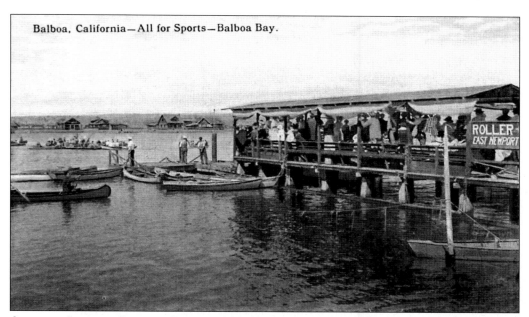

Balboa, California—All for Sports—Balboa Bay.

ALL FOR SPORTS, BALBOA BAY, C. 1920. Visitors wait to board launches to East Newport or Rocky Point.

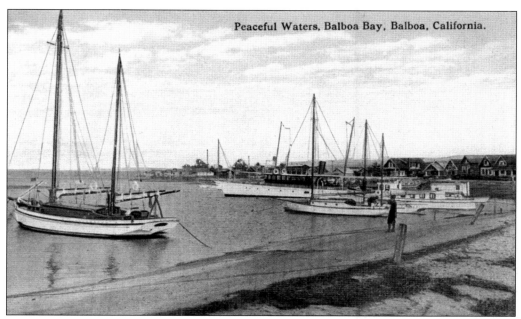

Peaceful Waters, Balboa Bay, Balboa, California.

PEACEFUL WATERS, BALBOA BAY, C. 1921. Today a mobile home park resides on the bay just east of this spot. This area remains one of the less crowded, more peaceful areas on the bay.

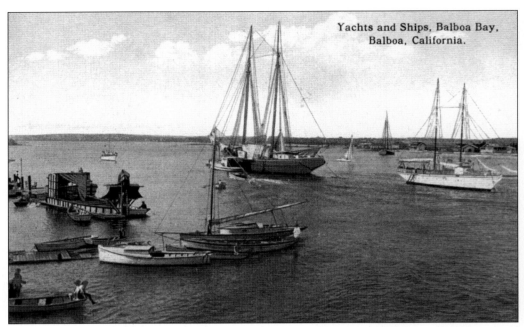

YACHTS AND SHIPS, BALBOA BAY, C. 1921. From rowboats to yachts, ships of all shapes and sizes have called Newport home.

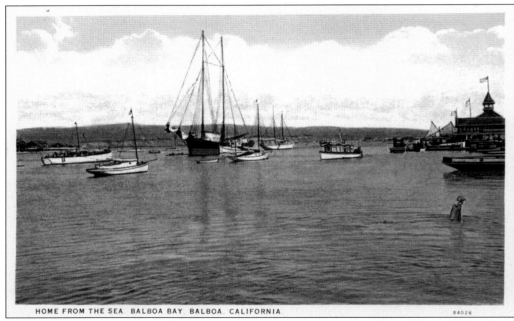

HOME FROM THE SEA, BALBOA BAY, C. 1921. Newport has been a place of boatbuilding since 1917, when Tom Broadway opened a shop on the peninsula. But nothing topped the Newport Beach Boat Works, which opened its doors in 1928 and took only two years to become the largest industry in the harbor district, with an annual payroll of $80,000.

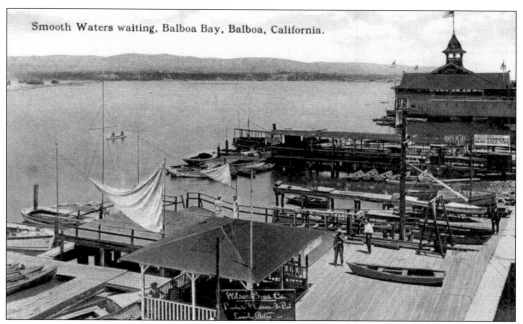

Smooth Waters waiting, Balboa Bay, Balboa, California.

SMOOTH WATERS WAITING, BALBOA BAY, C. 1921. The area just west of the pavilion offered many activities, including the ferry to Balboa Island, launches to Corona del Mar, and agents happy to rent you a boat or even roller skates.

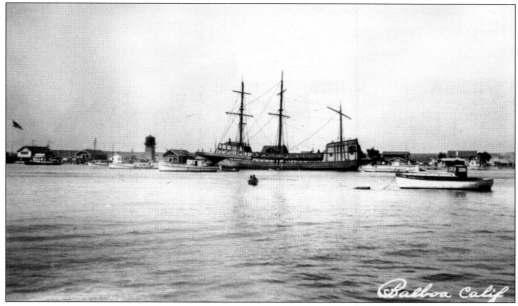

Balboa Calif

THE *CAPTAIN BLOOD* SHIP, C. 1924. This ship starred in *Captain Blood*, a 1924 silent film. The water tower to the left supplied fresh water for residents of Balboa Island.

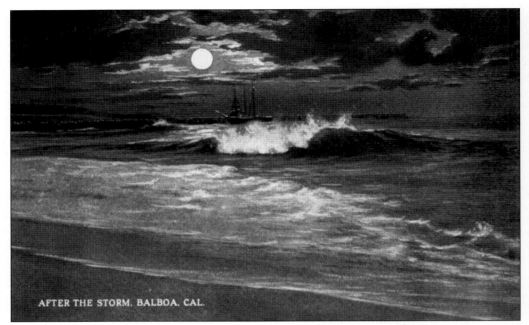

AFTER THE STORM, BALBOA, CAL.

AFTER THE STORM, BALBOA, C. 1920. When the sun sets and the daytime crowds depart, it's hard to find a more beautiful, romantic spot than the shores of Balboa Beach.

newport Beach, eaL.

NEWPORT PIER, C. 1921. By 1922, the pier was badly in need of repair and a liability to the Southern Pacific. When approached by city officials, the SP sold the pier and its land approach to the city for $5,000. In January 1923, the William Ledbettor Company added a T-end to the pie, and generally rebuilt the structure for the sum of $30,650.

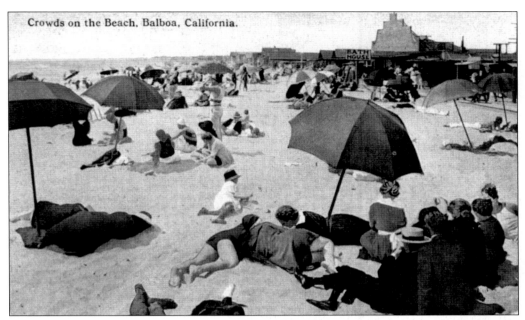

Crowds on the Beach, Balboa, California.

CROWDS ON THE BEACH, BALBOA, C. 1921. Throughout Newport's history, the summer months have brought multitudes to its beaches. Local businesses have to make the most of it or suffer in the less-crowded winter months.

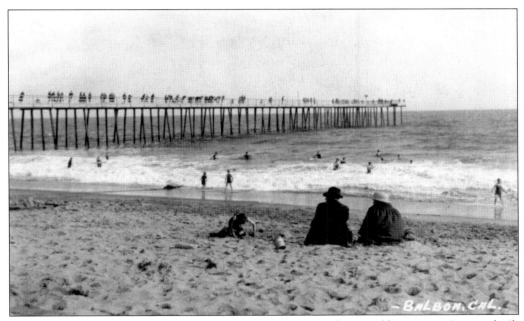

— BALBOA, CAL.

BEACH AND PIER, BALBOA, C. 1924. In 1939, the pier was destroyed by a storm. It was rebuilt the following year.

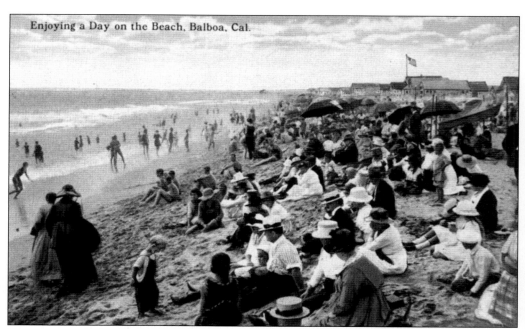

Enjoying a Day on the Beach, Balboa, Cal.

ENJOYING A DAY ON THE BEACH, BALBOA, C. 1920. In its early days, Newport could not afford to maintain a corps of paid lifeguards.

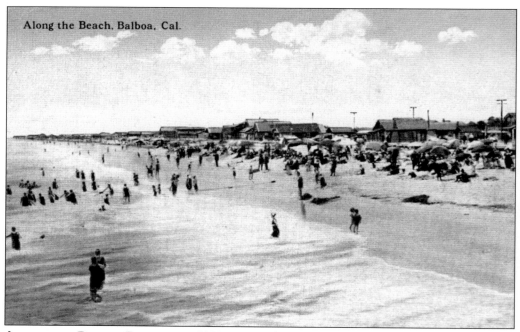

Along the Beach, Balboa, Cal.

ALONG THE BEACH, BALBOA, C. 1920. Novice bathers could take advantage of a safety line, a rope leading into the water from the beach.

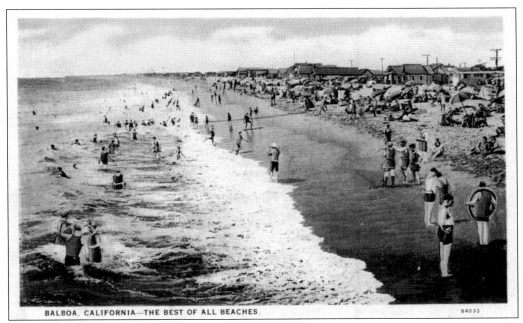

BALBOA, CALIFORNIA—THE BEST OF ALL BEACHES.

84033

BALBOA, THE BEST OF ALL BEACHES, C. 1921. Finally, in 1920, three men were employed as lifeguards—but only on Sundays during the summer season and on special holidays.

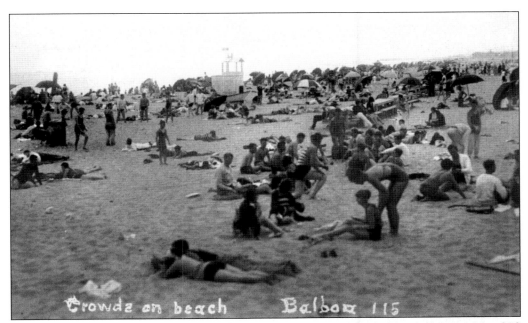

Crowds on beach Balboa 115

CROWDS ON THE BEACH, BALBOA, C. 1926. On May 18, 1923, ordinance No. 278 passed, creating a lifeguard service. A lookout tower was constructed in front of the Balboa Ocean Front Bathhouse, and for two years, a small emergency hospital room was maintained in that building.

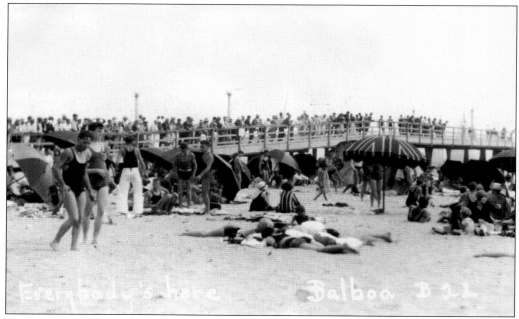

EVERYBODY'S HERE, BALBOA, C. 1928. Beginning in 1924, an ever-increasing number of men were employed to protect local bathers.

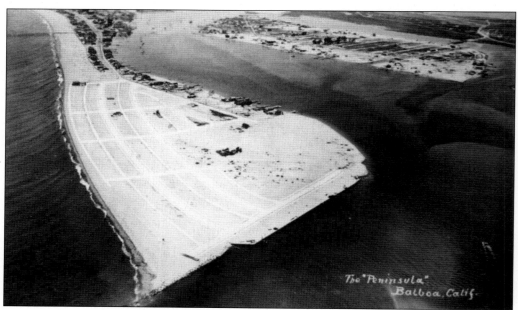

THE PENINSULA, BALBOA, C. 1922. In 1923, a syndicate of Pasadena men purchased all of the land on the easterly extreme of the peninsula from Edna Ferguson, the widow of Joe Ferguson. The property was then subdivided, a map filed in May 1923, and public improvements installed during the winter of 1923–1924, after which an intense selling campaign began.

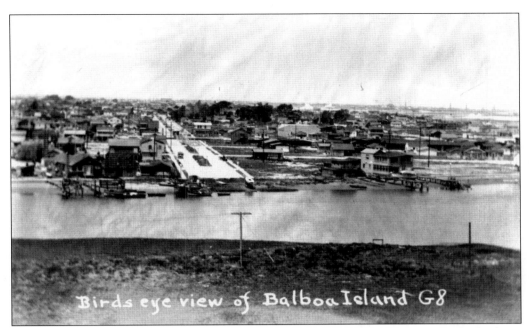

Birds eye view of Balboa Island G8

BIRD'S-EYE VIEW OF BALBOA ISLAND, C. 1928. In 1906, W. S. Collins commenced a dredging operation, partially completed by 1910, at which time a succession of subdivision map filings began. Prior to the dredging, the island was largely overflowed swamp land and mostly underwater at high tide. It was possible to row a boat over most of the area between the sand dunes.

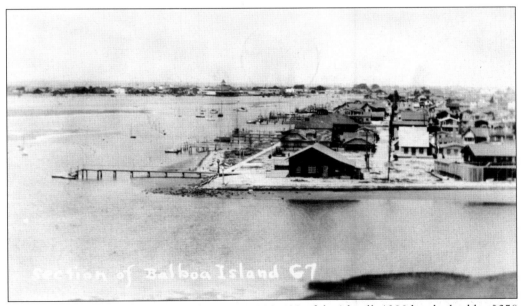

Section of Balboa Island G7

SECTION OF BALBOA ISLAND, C. 1928. By 1914, 700 of the island's 1300 lots had sold—$350 for inside lots and from $600 to $750 for those on the waterfront. The boom burst though when promised improvements, paved streets, sewers, streetlights, and a grand hotel, were not forthcoming. Property values dropped, and many were bought for taxes. In 1918, one parcel of 12 lots sold for $300.

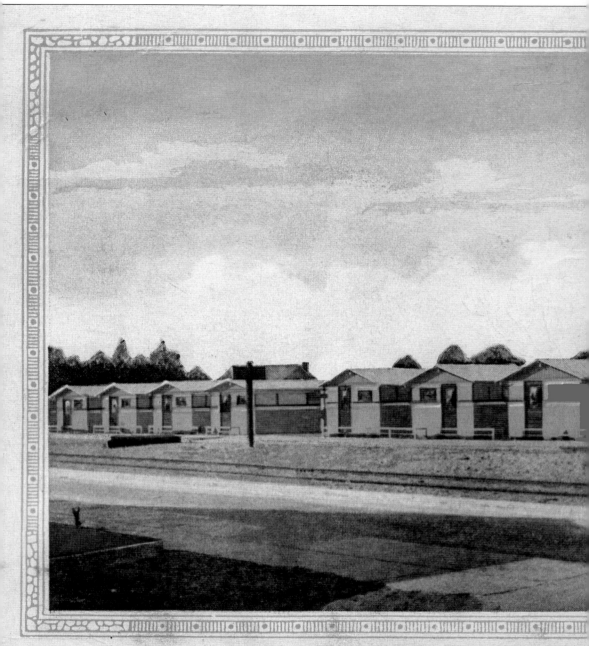

THE LITTLE YELLOW HOUSES

THE LITTLE YELLOW HOUSES WITH JAPANESE CURTAINS AT BALBOA, C. 1925. Everett Chase, one of the pioneer real estate men in town, arrived in Newport in 1903. With the financial backing of Dr. J. T. Rankin, he established Everett Chase's Little Yellow Houses on Cypress

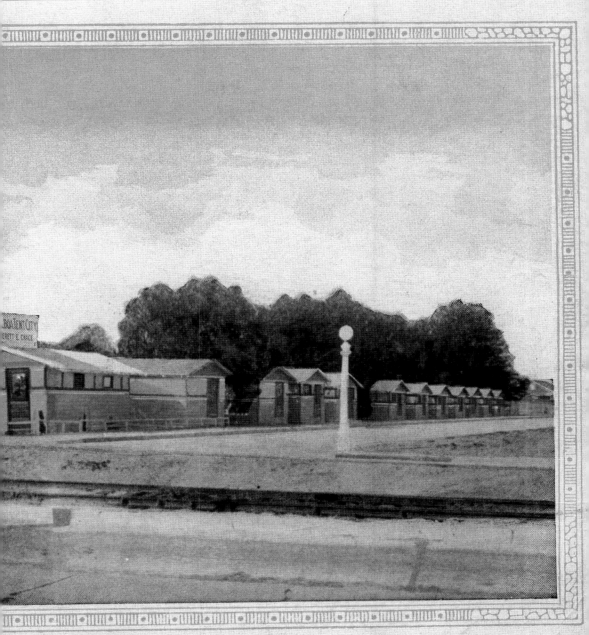

JAPANESE CURTAINS AT BALBOA

Street in 1912. The converted tents were furnished "in a most artistic manner" and included gas, electric lights, laundry, and house linen. In 1917, Chase bought Dr. Rankin's interest in the property.

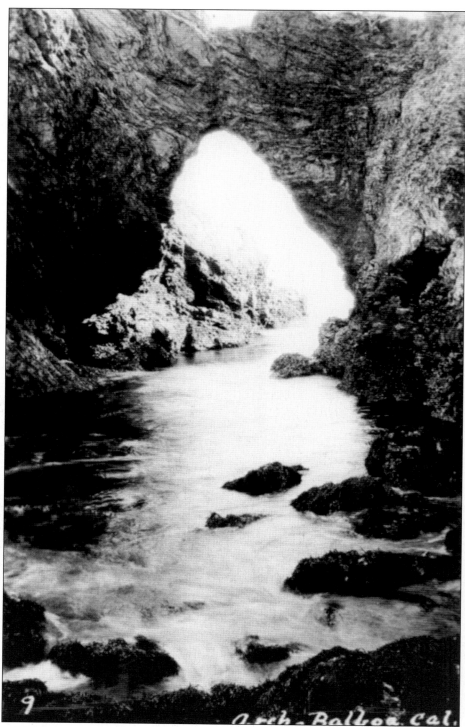

ARCH ROCK, BALBOA, C. 1929. Just off the coast of Corona del Mar, cormorants and other fish-eating birds have claimed Arch Rock as their own.

Four

THE 1930S

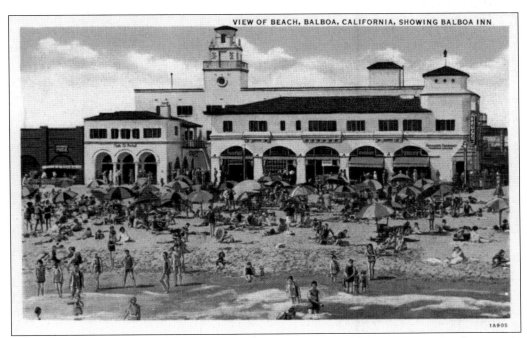

BALBOA INN, BALBOA, C. 1931. The Balboa Inn, constructed just west of the Balboa pier in 1929, was the finest hotel on the Orange County coast and the favored spot of movie stars and dignitaries. Over the years, the inn has been remodeled and modernized, but its graceful Spanish architecture remains virtually unchanged to this day.

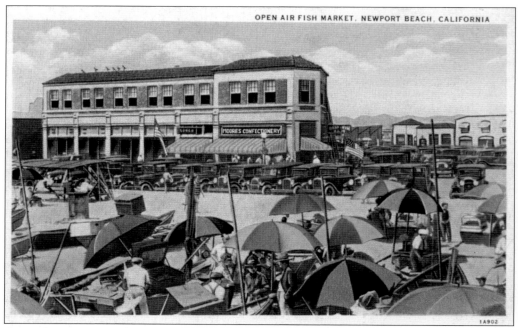

OPEN AIR FISH MARKET, NEWPORT BEACH, C. 1931. The building in the background still stands, housing the Doryman's Inn, an elegant bed and breakfast, and 21 Ocean Front, one of Newport's finest restaurants.

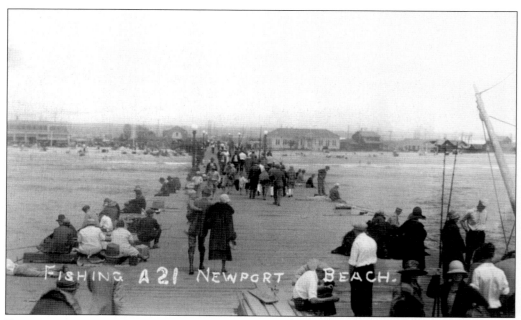

FISHING, NEWPORT BEACH, C. 1930. In the early 1930s, fishing from the Newport pier was the city's most popular tourist attraction.

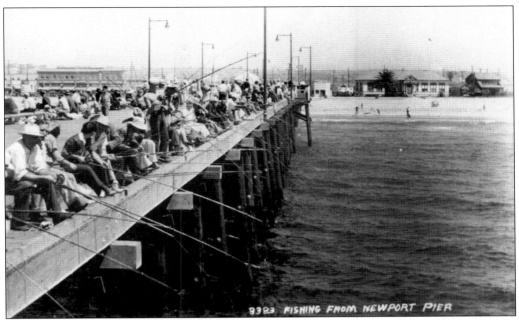

FISHING FROM NEWPORT PIER, C. 1939. Around 1939, it was estimated that 750,000 people per year dropped their lines from the deck of that structure.

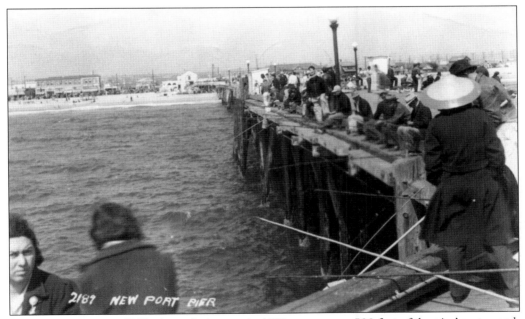

NEWPORT PIER, C. 1939. A tropical storm in 1939 swept away 500 feet of the pier's outer end. Today's municipal pier was built the following year.

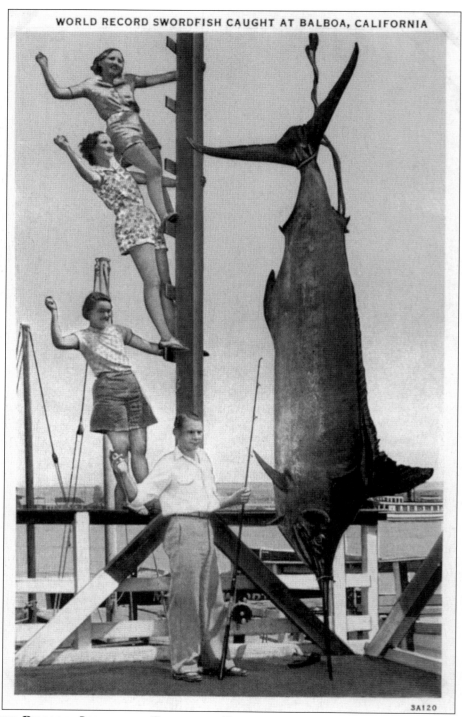

WORLD RECORD SWORDFISH CAUGHT AT BALBOA, CALIFORNIA

3A120

WORLD RECORD SWORDFISH CAUGHT AT BALBOA, C. 1931. On August 18, 1931, A. M. Hamman of Balboa caught this striped marlin swordfish, 13 feet, 5 inches in length, and weighing 692 pounds. At the time, it was the largest swordfish caught anywhere using standard tackle.

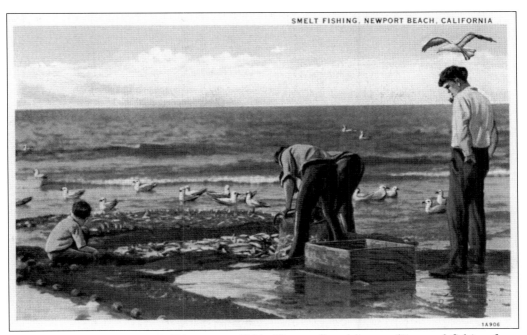

SMELT FISHING, NEWPORT BEACH, CALIFORNIA

SMELT FISHING, NEWPORT BEACH, *C.* 1931. Pier, surf, and bay angling, and fishing from various charter boats and local ocean barges, brought thousands of people to Newport who would not have come otherwise.

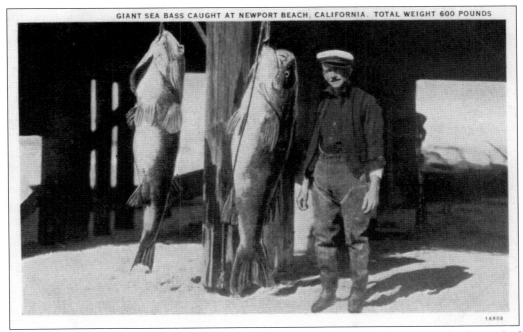

GIANT SEA BASS CAUGHT AT NEWPORT BEACH, CALIFORNIA. TOTAL WEIGHT 600 POUNDS

GIANT SEA BASS, *C.* 1931. These giant sea bass, caught at Newport Beach, weighed a total of 600 pounds. The card promoted Newport as the fishing spot "where the big ones don't always get away."

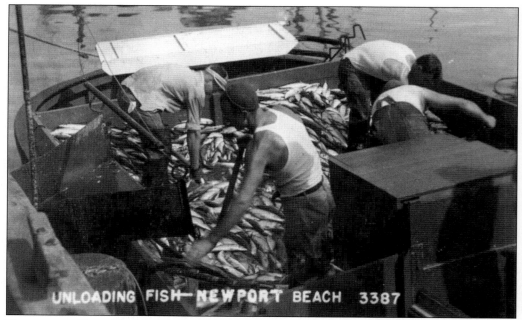

UNLOADING FISH, NEWPORT BEACH, C. 1939. The commercial fishing industry in Newport was a major source of income. At one time, commercial and sport fishing combined accounted for nearly 90 percent of the gross income of the city.

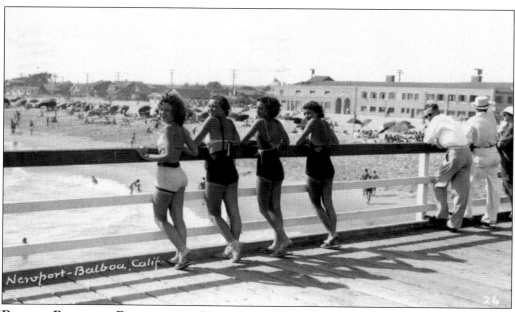

BALBOA PIER AND RENDEZVOUS BALLROOM, C. 1935. Here is a glimpse of the ballroom (right), built in 1928 by developers Harry "Pop" Tudor and Ray Burlingame as a competing dance hall to the pavilion. The construction cost was $200,000. Visitors, like the young ladies pictured here, filled the beach by day and the ballroom's dance floor at night.

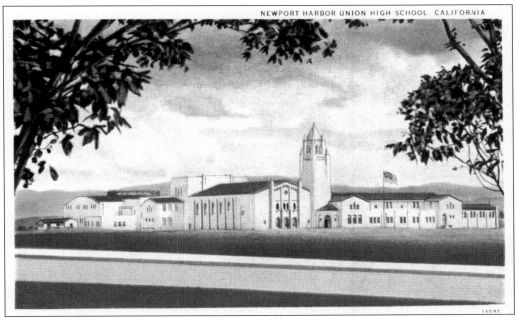

NEWPORT HARBOR UNION HIGH SCHOOL, C. 1931. The high school opened in September 1930, with 200 students and two dozen faculty members. Mosaic murals in the quad were completed as a WPA art project.

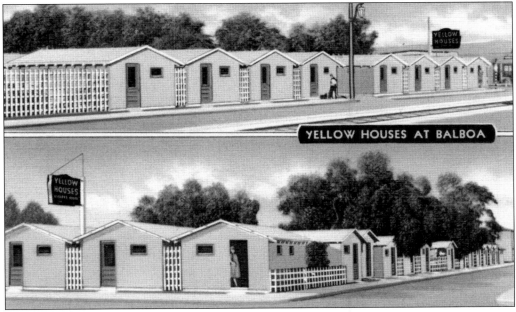

YELLOW HOUSES AT BALBOA, C. 1939. By the early 1930s, Everett Chase's Yellow Houses at Balboa had grown from 24 (in 1912) to 61 modern, "cozy and clean" bungalows.

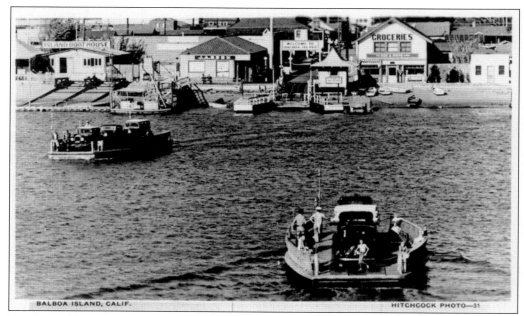

FERRY TO BALBOA ISLAND, C. 1934. On August 9, 1909, W. S. Collins got the first city ferry permit. Other operators followed, but the service was deemed unsatisfactory. Finally, in 1919, pioneer developer Joseph A. Beek won the city contract to operate the Balboa–Balboa Island ferry. In 1921, new ferries carried autos rather than pushing them on small barges.

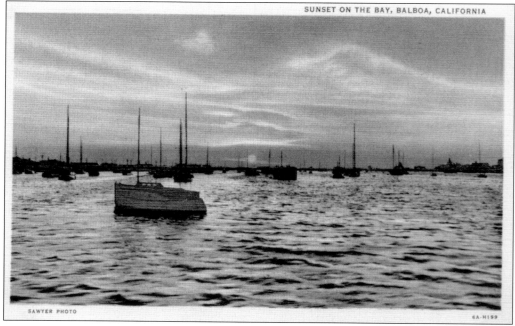

SUNSET ON THE BAY, BALBOA, C. 1936. A walk along the bay at sunset is a favorite activity of residents and visitors alike.

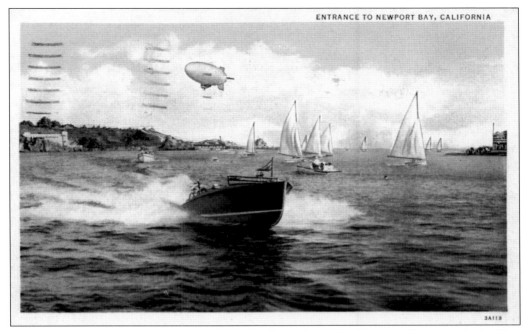

3A113

ENTRANCE TO NEWPORT BAY, C. 1933. By the early 1930s, Newport Bay was the leading pleasure harbor on the Pacific coast.

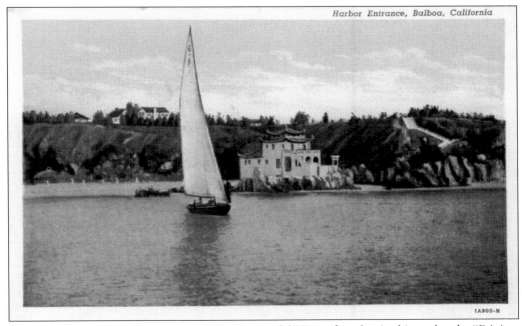

Harbor Entrance, Balboa, California

1A900-N

HARBOR ENTRANCE, BALBOA, C. 1931. Corona del Mar, referred to in this card as the "Riviera of America," offers a magnificent view of both the Pacific Ocean and Newport Bay.

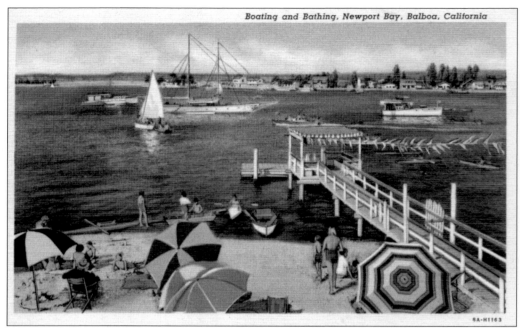

BOATING AND BATHING, NEWPORT BAY. This *c.* 1938 postcard promotes Newport Beach as "a delightful recreational community with boating, bathing, fishing, and all seaside activities throughout the year, a mecca of vacationists."

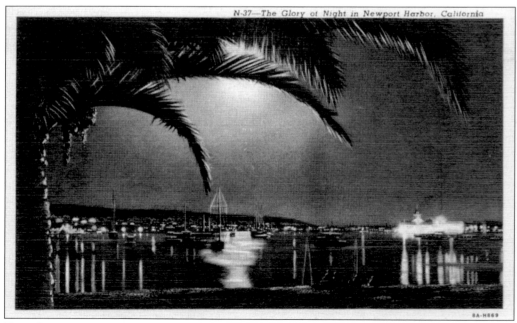

THE GLORY OF NIGHT IN NEWPORT HARBOR, C. 1938. "When nightfall comes to Newport Harbor, the reflected lights from homes that dot the shores, and from boats bobbing at anchor in the bay, glittering and sparkling like thousands of jewels, present an unforgettable sight."

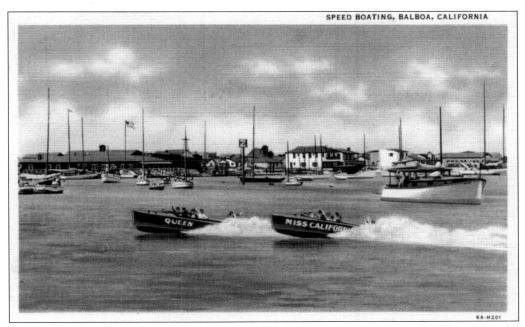

6A-H201

SPEED BOATING, BALBOA, c. **1936.** Before the late 1930s, there was no speed limit in the bay. Two 35-foot boats, the *Queen* and the *Miss California*, with approximately 10 passengers each, would take off full speed from the pavilion, sirens blaring, and race out of the bay into the Pacific. Today the speed limit is five miles per hour.

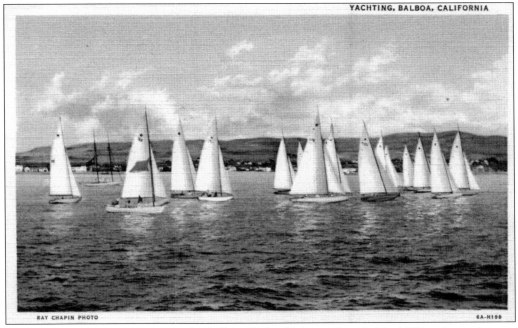

RAY CHAPIN PHOTO 6A-H198

YACHTING, BALBOA, c. **1936.** The Balboa Yacht Club was founded in 1922 and remains one of the oldest clubs on the Pacific coast. Today it is recognized as one of the premiere yachting facilities on the West Coast and conducts an active junior sailing program.

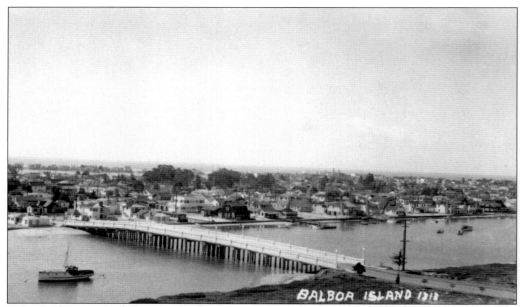

BALBOA ISLAND BRIDGE, C. 1937. In 1912, W. S. Collins hired Joe Beek to construct a bridge connecting Balboa Island to the mainland. The 12-foot-wide wooden bridge, used to transport building materials and supplies by horse and wagon, stood for 12 years before being replaced by the one seen here.

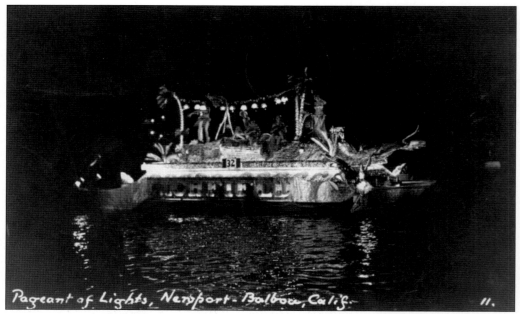

PAGEANT OF LIGHTS, NEWPORT-BALBOA, C. 1932. A Venetian gondolier named John Scarpa is credited with creating Balboa's first lighted boat parade—the Illuminated Light Parade, first held on August 23, 1908. It later took on other names such as the Tournament of Lights, Pageant of Lights, and Festival of Lights. Originally held during the summer, it is now a fixture of the Christmas season.

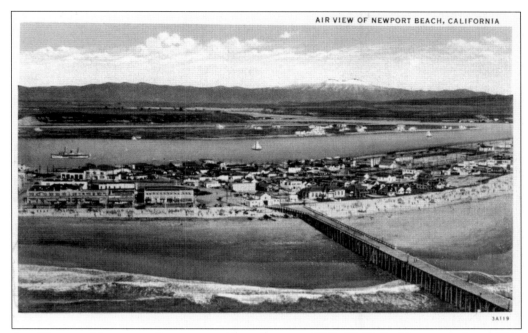

AIR VIEW OF NEWPORT BEACH AND LIDO ISLE, *C.* 1933. W. K. Parkinson purchased Lido Isle in 1923 for $45,000 and spent $261,000 filling the land with dredging materials. Wanting to use Lido for commercial purposes, he ignored any proposition not along those lines. In 1926, he sold the property to William Clark Crittenden for $1.25 million.

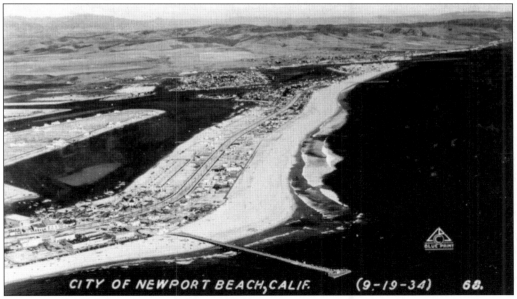

CITY OF NEWPORT BEACH, CALIF. (9-19-34) 68.

CITY OF NEWPORT BEACH, *C.* 1934. Public improvements were made to Lido (left), including sidewalks, curbs, pavements, streetlights, water and sewer mains, an underground wiring system for telephone and electric service, pleasure piers, and a bridge connecting the island to the mainland, but the economic depression resulted in few lot sales. This aerial shot shows only a few dozen houses on the island.

85

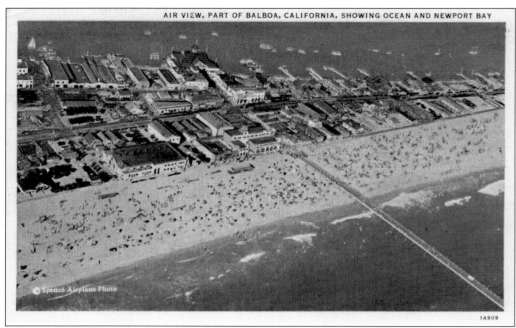

AIR VIEW, PART OF BALBOA, CALIFORNIA, SHOWING OCEAN AND NEWPORT BAY

1A909

AIR VIEW, *C.* **1931.** This card illustrates the close proximity of the Balboa Inn (center), the Rendezvous Ballroom (left of center), and the Balboa Pavilion (top, left of center). The aerial view also shows the ocean and part of Newport Bay.

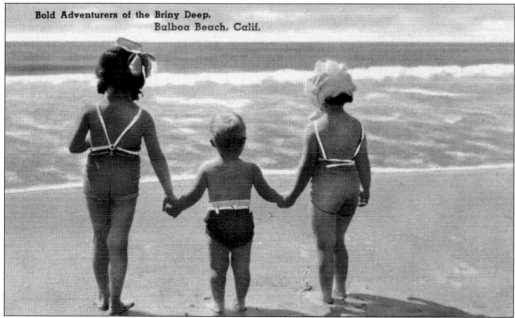

Bold Adventurers of the Briny Deep,
Balboa Beach, Calif.

BOLD ADVENTURES OF THE BRINY DEEP, BALBOA, *C.* **1935.** Despite the Great Depression, government funding of harbor projects resulted in a growing optimism for Newport's future, illustrated in many postcards of the period.

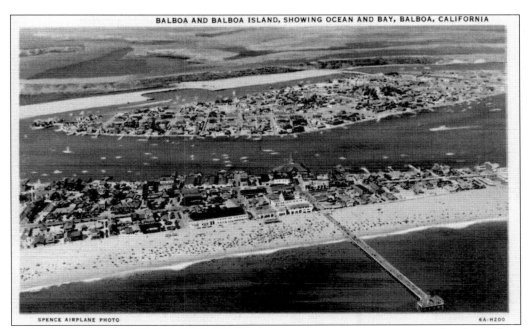

SPENCE AIRPLANE PHOTO

6A-H200

BALBOA AND BALBOA ISLAND, SHOWING OCEAN AND BAY, C. 1936. After $4 million in improvements, Pres. Franklin D. Roosevelt dedicated the new harbor by telegraph from Washington, D.C. The same year, the senate approved $13 million for Orange County flood projects.

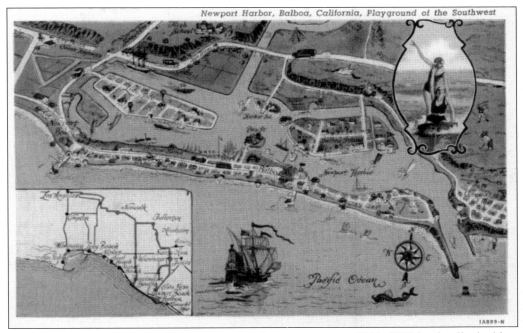

Newport Harbor, Balboa, California, Playground of the Southwest

IA899-N

NEWPORT HARBOR, PLAYGROUND OF THE SOUTHWEST, C. 1931. "With a landlocked bay and miles of clean, sandy beach, with a climate unsurpassed 12 months of the year in all America, Newport-Balboa is a playground supreme."

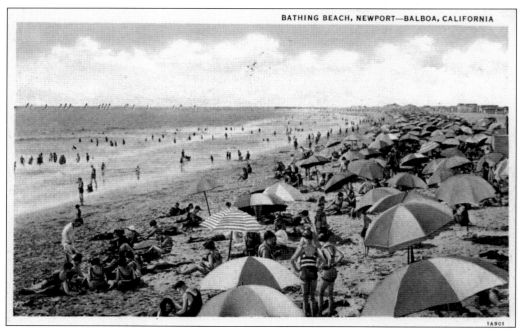

BATHING BEACH, NEWPORT–BALBOA, C. 1931. According to this postcard, "Newport–Balboa is the Southwest's great port of pleasure."

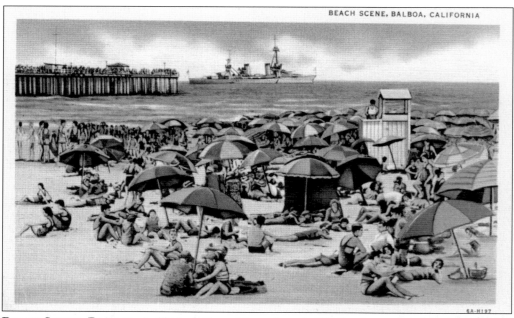

BEACH SCENE, BALBOA, C. 1936. A Navy ship anchored off Balboa's coast would be a surprising sight today, but not so in the 1930s. A Navy ship often arrived to take part in the Tournament of Lights celebration.

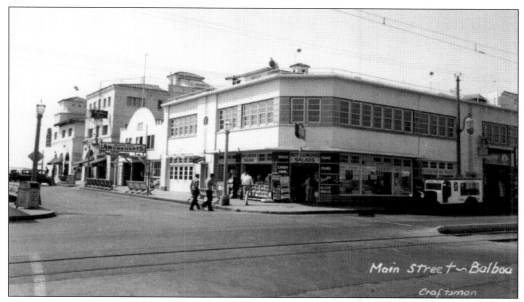

MAIN STREET, BALBOA, C. 1939. On the southwest corner of Main Street and Central Avenue, an Arden milk truck is parked at the curb, and the J. L. Bakery is on the far right. A sign above the door (left of center) advertises a roof garden above the McCoy Drug Company.

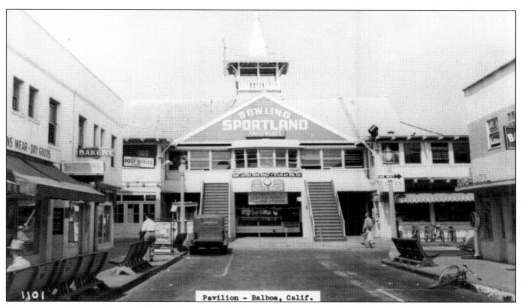

PAVILION, BALBOA, C. 1939. Among the businesses occupying the pavilion in the late 1930s were a seafood market and bowling alley.

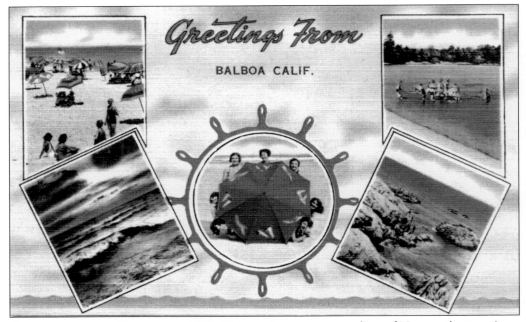

GREETINGS FROM BALBOA, C. 1935. This card presents a sampling of Newport's attractions, enjoyed by both residents and visitors.

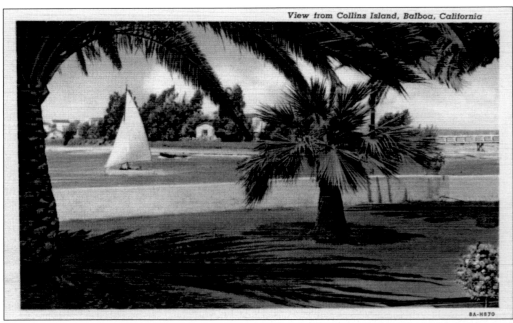

VIEW FROM COLLINS ISLAND, BALBOA, C. 1938. Collins Island was famous for the castle William S. Collins built for his fourth wife, Apolena. The castle, owned for a time in the 1930s by Jimmy Cagney's brother, was used as an emergency center by the U.S. Coast Guard for the duration of World War II.

Five

THE 1940S

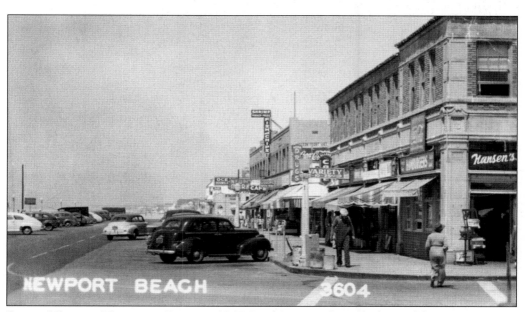

SHOPS WEST OF NEWPORT PIER, C. 1947. Looking west from the base of the Newport Pier, businesses and shops can be seen in Newport Beach. Switch out the old cars and business signs, and the view today would be remarkably unchanged.

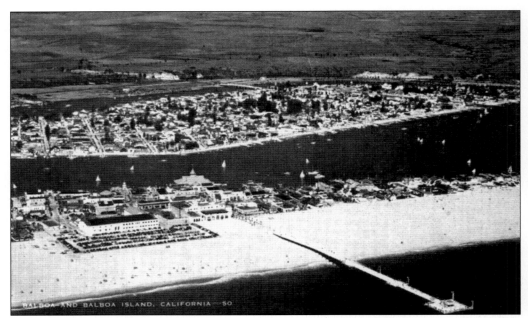

BALBOA AND BALBOA ISLAND, C. 1944. The new municipal parking lot is visible (left of center) in front of the Rendezvous Ballroom.

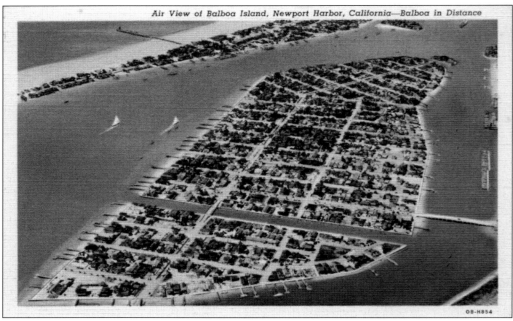

AIR VIEW OF BALBOA ISLAND, BALBOA IN DISTANCE, C. 1940. Believing that a beach name might be too limiting for a growing city, a number of residents wished to change the city's name from Newport Beach to Balboa. In 1940, the city council put the matter on the ballot. It was defeated 1,014 to 581.

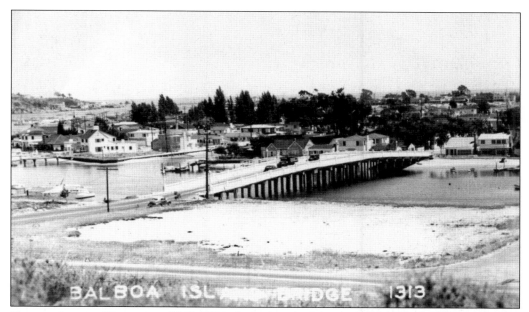

BALBOA ISLAND BRIDGE, C. 1942. With the harbor dredging in 1935–1936 and the construction of the promenade and bulkhead in 1937, property values increased significantly on the island.

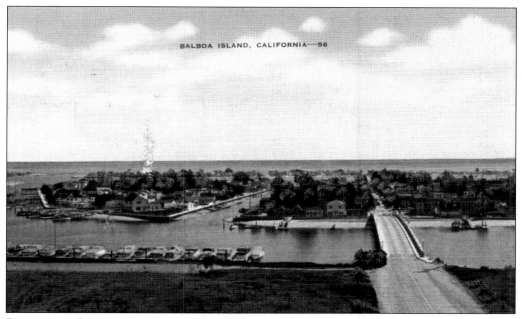

BALBOA ISLAND, CALIFORNIA—56

BRIDGE TO BALBOA ISLAND, C. 1944. The end of the war in 1945 resulted in a population explosion, as thousands of servicemen from the Santa Ana Air Base moved to Newport, and particularly Balboa Island. This contributed greatly to Newport's transformation from a summer getaway to a town of year-round residents.

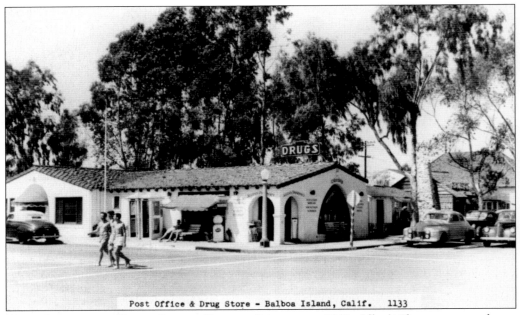

Post Office & Drug Store - Balboa Island, Calif. 1133

POST OFFICE AND DRUG STORE, BALBOA ISLAND, C. 1941. Allen's Pharmacy was always the perfect spot for fountain service on a hot day.

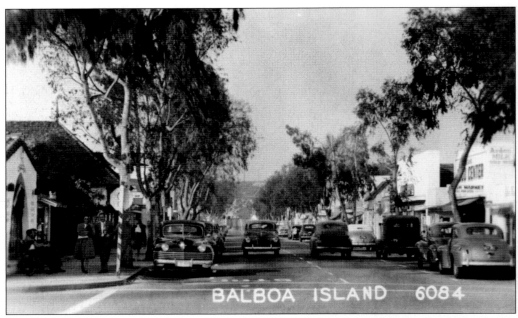

BALBOA ISLAND 6084

MARINE AVENUE, BALBOA ISLAND, C. 1947. The business district of the island, lined with popular shops and restaurants, included the Jolly Roger and Dad's Donut Shop and Bakery.

94

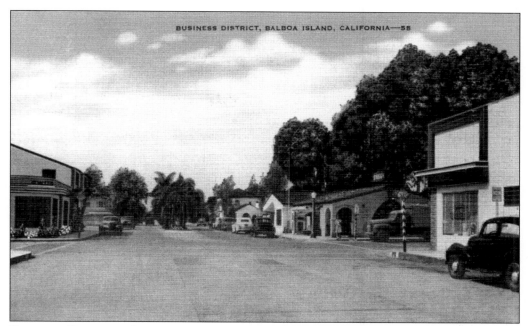

BUSINESS DISTRICT, BALBOA ISLAND, C. 1944. Today it is hard to imagine that this unique, picturesque island was once merely a collection of mudflats and sandbars, mostly underwater at high tide.

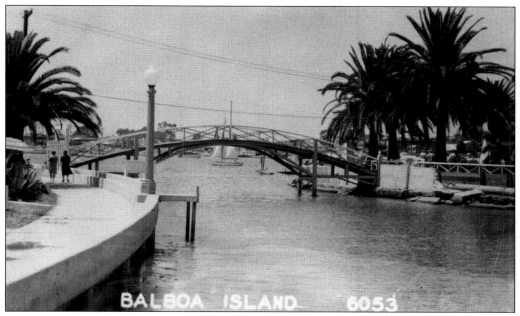

BALBOA ISLAND, C. 1942. This postcard shows the bridge from the western tip of the island to Collins Island.

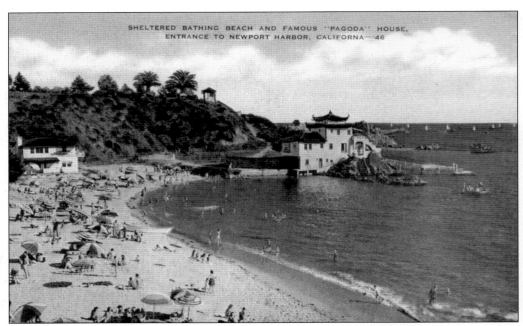

SHELTERED BATHING BEACH AND FAMOUS PAGODA HOUSE, NEWPORT HARBOR, C. 1944.
A fixture of the bay, the Pagoda House, or China House, stood sentinel near the mouth of the harbor for decades.

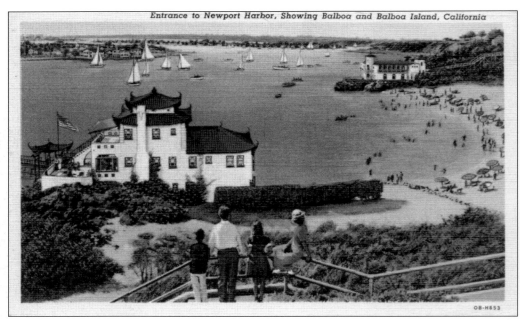

ENTRANCE TO NEWPORT HARBOR, SHOWING BALBOA AND BALBOA ISLAND, C. 1940.
Slated for demolition, there was a last ditch effort to gain protective status for the Pagoda House landmark, but the effort was too little, too late.

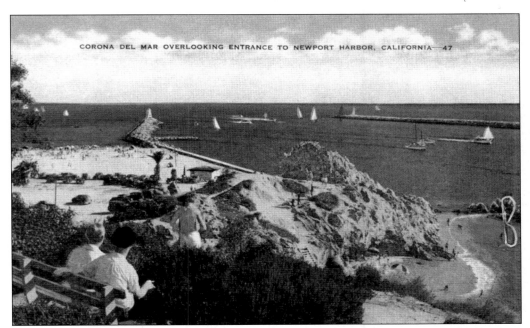

CORONA DEL MAR, C. 1944. Overlooking the entrance to Newport Harbor is the perfect spot for spectacular views of Corona del Mar State Beach, the harbor entrance, the Balboa Peninsula, and on a clear day, Catalina Island.

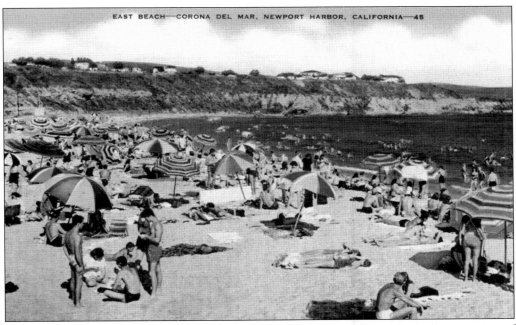

EAST BEACH, CORONA DEL MAR, NEWPORT HARBOR, C. 1944. Before the extension of the jetties in the late 1930s, Corona del Mar was known for its surfing, even hosting the Pacific Coast Surfboard Championship in 1928. The longer jetties ended the "killer break" at Corona del Mar, signaling the demise of surfing at that beach.

97

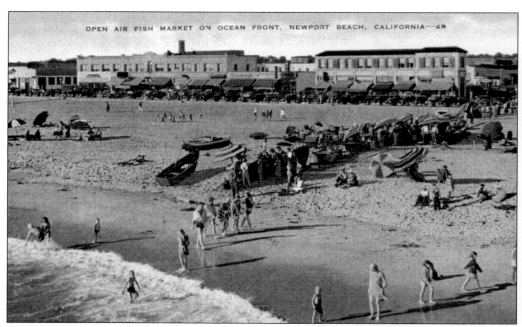

OPEN-AIR FISH MARKET ON OCEAN FRONT, NEWPORT BEACH, C. 1944. Dory fishermen work at night, delivering their catch as the sun rises.

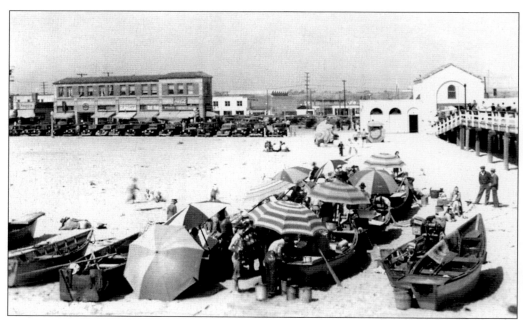

FISH MARKET, NEWPORT BEACH, C. 1943. In the 1890s, the fishermen's wives began selling each day's catch in booths set up beneath the Newport Pier. The dory fishermen continue to operate today.

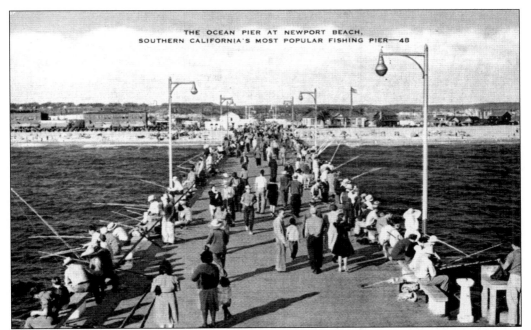

THE OCEAN PIER AT NEWPORT BEACH,
SOUTHERN CALIFORNIA'S MOST POPULAR FISHING PIER—48

OCEAN PIER AT NEWPORT BEACH, C. 1944. Built after the disastrous tropical storm of 1939, the new municipal pier is Southern California's most famous fishing pier. During the storm, many small craft were destroyed, and a number of people drowned.

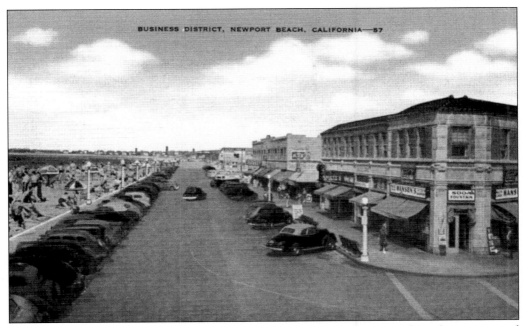

BUSINESS DISTRICT, NEWPORT BEACH, CALIFORNIA—57

BUSINESS DISTRICT, NEWPORT BEACH, C. 1944. The two buildings on the right, constructed in the 1920s, still stand, and contribute greatly to the area's charm.

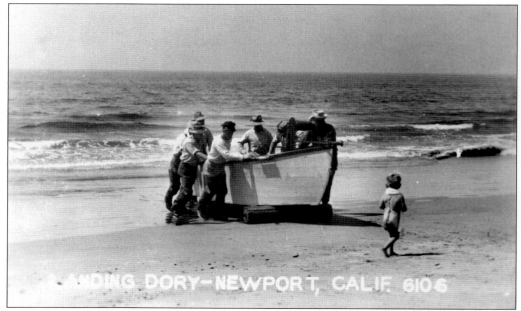

LANDING DORY, NEWPORT, C. 1940. Dory fishermen were beached for the duration of World War II. Fishermen remained active on both piers, commercial fishing vessels, and from the surf.

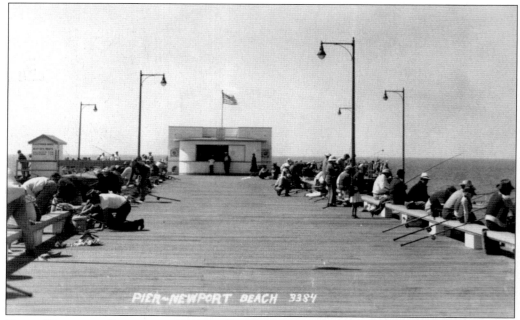

PIER, NEWPORT BEACH, C. 1940. Balboa's second pier, built in 1921, was destroyed by a massive storm in 1939. In 1940, a new pier was built. The structure at the end of the pier was eventually remodeled and became the first Ruby's Diner, where fine burgers and fountain drinks can still be had today.

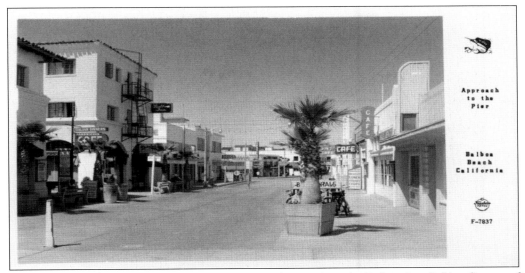

APPROACH TO THE PIER, BALBOA, C. 1941. At this writing, the Balboa Inn (left), a fixture of the village since 1929, is expanding its facilities. Soon guests will enjoy new shops, spectacular pool facilities, and 12 new rooms.

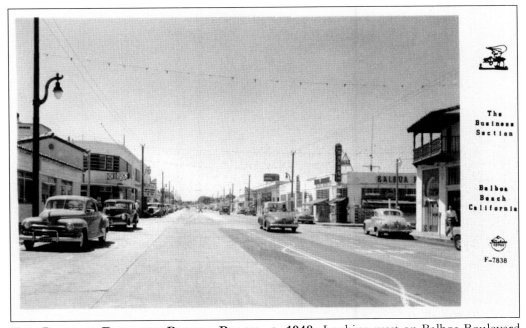

THE BUSINESS DISTRICT, BALBOA BEACH, C. 1948. Looking west on Balboa Boulevard towards its intersection with Main Street, the marquis of the Balboa Theatre (left) advertises Jeanette MacDonald in *Three Daring Daughters*.

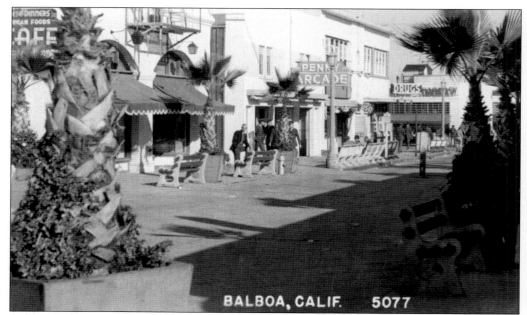

MAIN STREET, BALBOA, C. 1944. Note the USO club entrance, just to the right of the light post, and the numerous men in uniform on the sidewalk and crossing the intersection. Balboa was a popular destination for men on leave from the nearby Santa Ana Air Base.

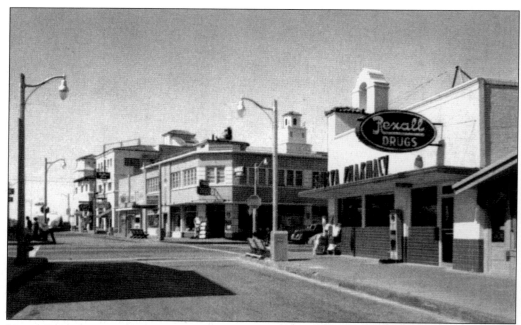

MAIN STREET AND BALBOA BOULEVARD, C. 1941. A drugstore has resided on the corner of Main Street and Balboa Boulevard since the early 1920s. It is likely that the majority of postcards presented in this book were purchased within its doors.

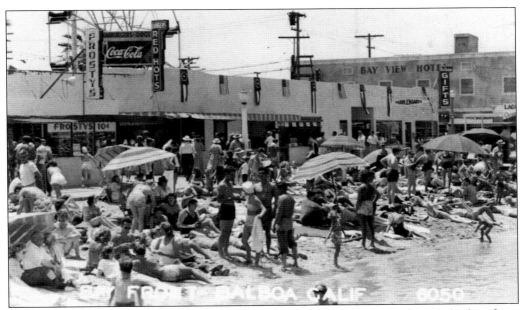

BAY FRONT, BALBOA, C. 1940. In 1936, entrepreneur Al Anderson leased the bay front area between Washington Street, Palm Street, and Bay Avenue from Fred Lewis. Anderson cleared the land and began putting up amusement features. He christened his new amusement park the Fun Zone.

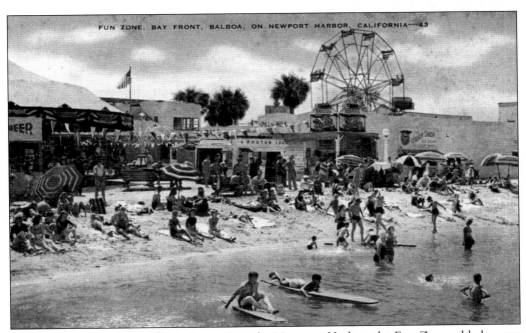

FUN ZONE, BALBOA, C. 1944. Located on the Newport Harbor, the Fun Zone added games and rides over the years, including bumper cars, a merry-go-round, and a Ferris wheel.

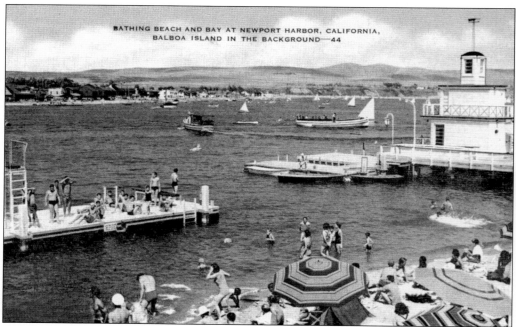

BATHING BEACH AND BAY AT NEWPORT HARBOR, C. 1944. The harbor master's pier is visible on the far right. Balboa Island can be seen in the distance.

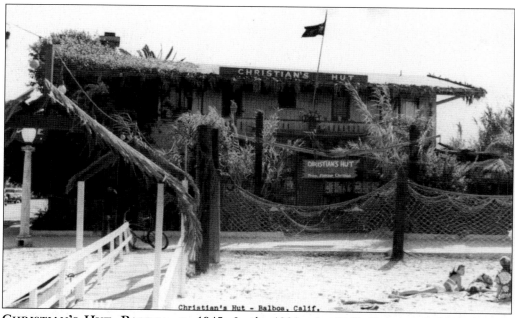

CHRISTIAN'S HUT, BALBOA, C. 1945. In the 1930s, Art LaShelle opened this Tahitian-style bayfront restaurant. The sand-floored, ground-level bar was a favorite of Howard Hughes and Humphrey Bogart. The structure burned in 1963, and Newport Towers occupies the site today.

Six

THE 1950S

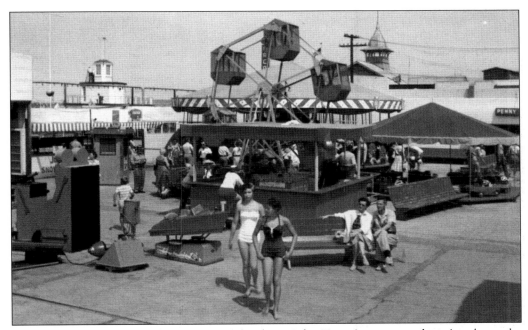

FUN ZONE, BALBOA, C. 1958. In 1972, developer John Konwiser proposed tearing down the Fun Zone to erect a condominium project. Luckily the newly created State Coastal Commission sided with a group of Newport residents who felt the Fun Zone property should remain available to the public. The project was blocked, and families continue to enjoy the Fun Zone to this day.

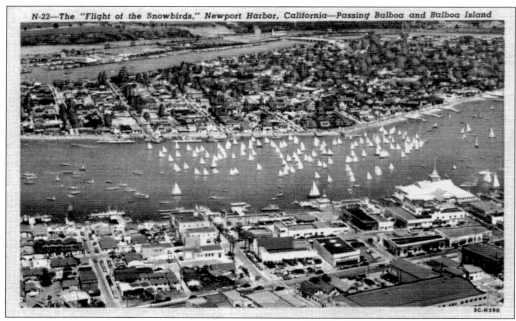

THE FLIGHT OF THE SNOWBIRDS, PASSING BALBOA AND BALBOA ISLAND, C. 1953. Begun in 1935, the annual Flight of the Snowbirds was conducted by the chamber of commerce for boys and girls, to stimulate interest in sailing among the youth of Newport Beach. It was so named because of the resemblance of over 100 sails to a flock of migrating snowbirds.

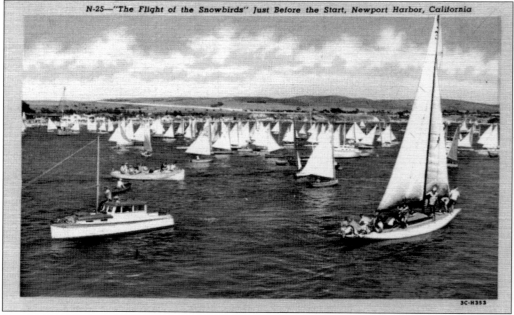

THE FLIGHT OF THE SNOWBIRDS, NEWPORT HARBOR. This c. 1953 postcard shows the "snowbirds" just before the start of the race. The first 10 skippers to finish the race received awards, as did the youngest boy and girl. In 1948, 148 craft entered the race, and all but eight finished the course.

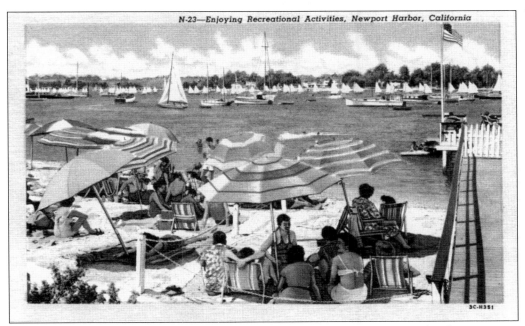

3C-H351

ENJOYING RECREATIONAL ACTIVITIES, NEWPORT HARBOR, C. 1953. A familiar site, even today, on the bay side boardwalk between the Pavilion and Bay Island.

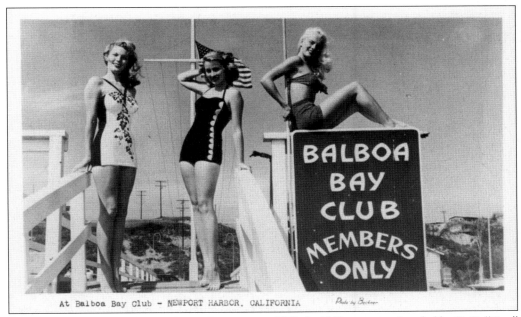

At Balboa Bay Club - NEWPORT HARBOR, CALIFORNIA *Photo by Bechner*

AT BALBOA BAY CLUB, NEWPORT HARBOR, C. 1951. In 1948, a consortium led by K. T. "Ken" Kendall, founded this family membership club on land used during the war as mooring for a fleet of old schooners used for offshore anti-submarine patrol. The club became a favorite hideaway for the likes of John Wayne and Barry Goldwater. Humphrey Bogart romanced Lauren Bacall there. Kings, prime ministers, and presidents enjoyed the club's ambiance and hospitality.

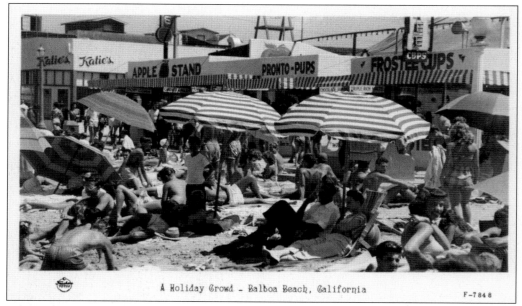

A Holiday Crowd – Balboa Beach, California

F-7848

A HOLIDAY CROWD, BALBOA BEACH. This is the bay side beach, just west of the pavilion, *c.* 1952. Bathers and sunbathers needing nourishment could enjoy triple rich malts, candied apples, and popcorn.

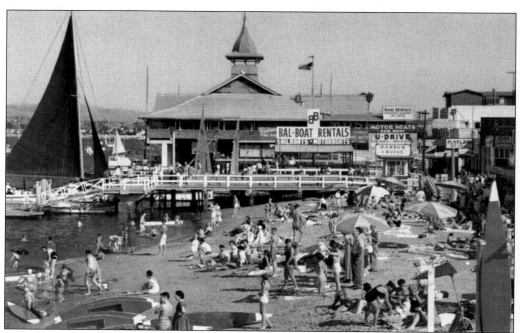

FUN ZONE BEACH, BALBOA, C. 1959. The sailboat on the left is the trim auxiliary sloop *Bay Queen.*

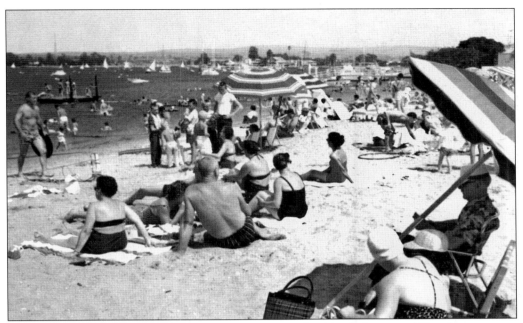

THE PUBLIC BEACH ON THE BAY, C. 1959. Located at Tenth Street and Bay Avenue, near the Newport Harbor Yacht Club, this public beach continues to be enjoyed by residents and visitors today.

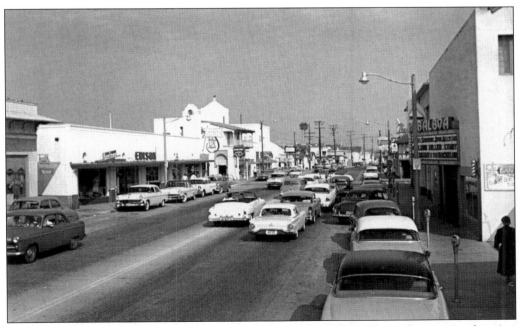

LOOKING EAST ON BALBOA BOULEVARD, C. 1958. The Balboa Theatre's marquis advertises a double bill of *The Glenn Miller Story* and *Tammy and the Bachelor*. The theatre closed in 1992, but the Balboa Performing Arts Theatre Foundation hopes to reopen the venerable landmark in 2008.

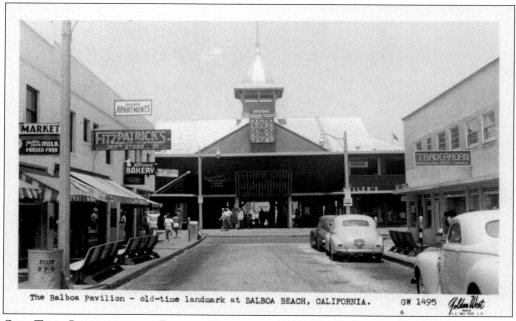

The Balboa Pavilion – old-time landmark at BALBOA BEACH, CALIFORNIA. GW 1495

OLD-TIME LANDMARK AT BALBOA BEACH, *C.* **1950.** The Balboa Pavilion's balconies were removed when the structure was remodeled as a department store.

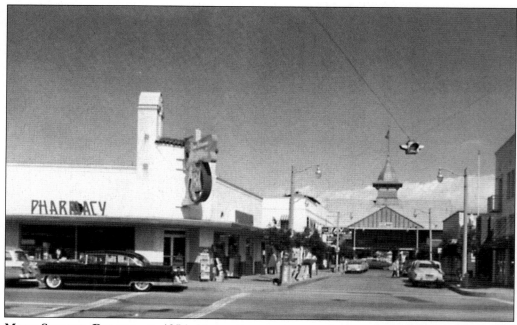

MAIN STREET, BALBOA, *C.* **1956.** Many attempts were made to modernize the pavilion in the 1940s and 1950s. The building slowly fell into almost total disrepair.

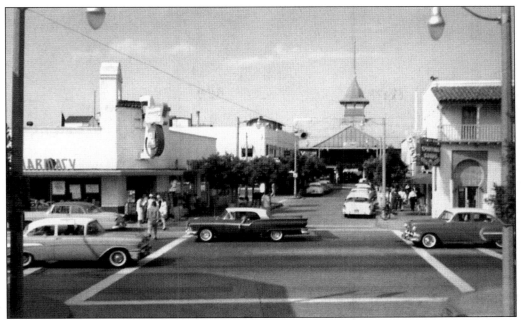

MAIN STREET AND BALBOA BOULEVARD, C. 1959. The pavilion was saved by the Gronsky family, who replaced its understructure and most of its exterior. Much later, the building was sold to Phil Tozer, who, with partners, completed the interior restoration.

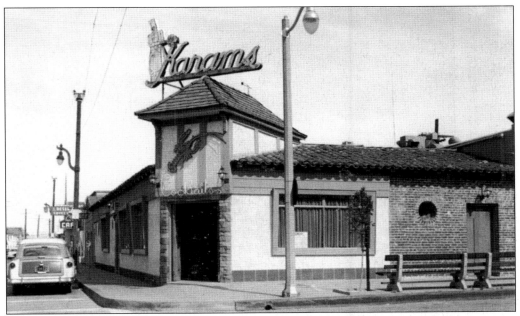

KARAM'S, CORNER OF MAIN STREET AND BALBOA BOULEVARD, C. 1953. In the early 1950s, Karam's was the most elite restaurant in Balboa. Parking valets wore tuxedos to park the cars of upper-crust patrons. In 1953, Karam's threw a fund-raiser for George Hoag to help open Hoag Hospital. Over 125 people attended at $100 a plate. The building is currently occupied by the Shore House Cafe.

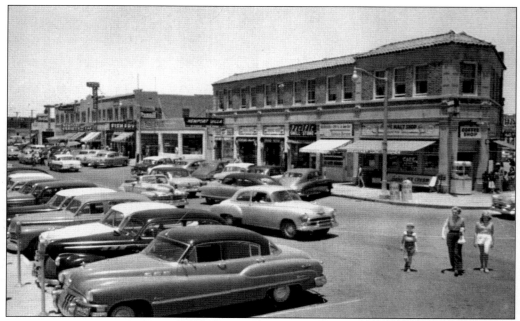

BUSINESS BLOCK AT BASE OF NEWPORT PIER, C. 1955. Finding a parking spot near the Newport Pier was as problematic a half-century ago as it is today.

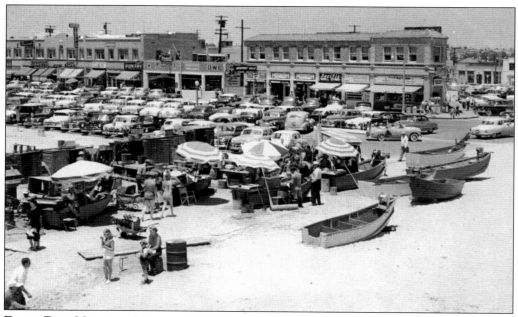

DORY FISH MARKET, NEWPORT BEACH, C. 1955. The city council has declared that only vessels of the original dory design can be stored and launched on the public beach.

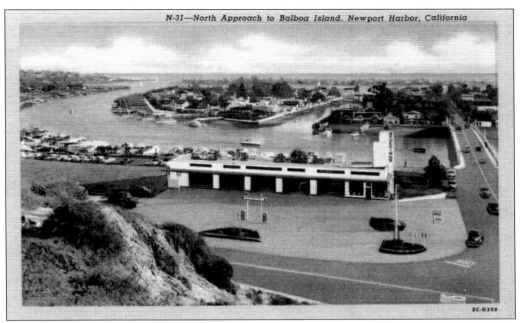

NORTH APPROACH TO BALBOA ISLAND, NEWPORT HARBOR, C. 1953. Balboa Island, the largest island in the harbor, is accessible only by this bridge and the auto ferry from the Balboa Peninsula.

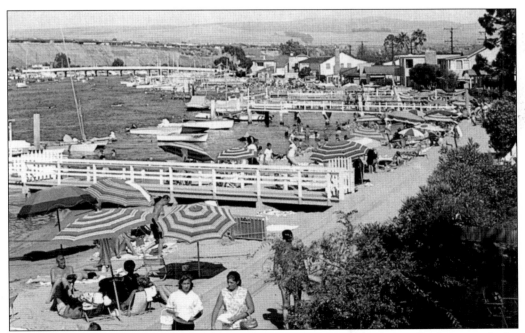

NORTH BAY FRONT, BALBOA ISLAND. This *c.* 1959 postcard looks southwest towards the Marine Avenue Bridge, which connects the island to Pacific Coast Highway.

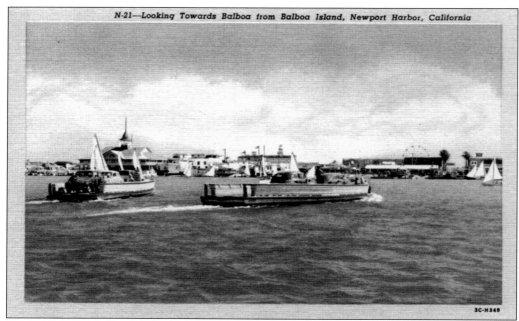

LOOKING TOWARDS BALBOA FROM BALBOA ISLAND, NEWPORT HARBOR, C. 1953. The Beek family, who obtained the city contract to run the Balboa Ferry back in 1919, continues to operate the ferry today.

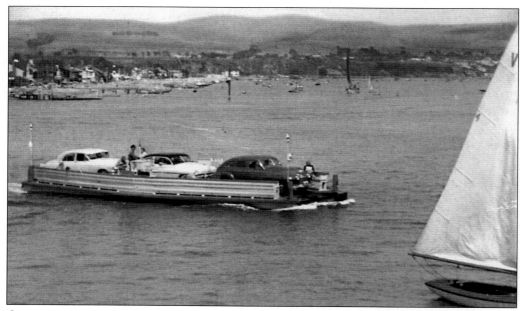

COLORFUL FERRIES CONNECT BALBOA AND BALBOA ISLAND, C. 1956. Joseph Beek's first boat used as a ferry was an outboard named *The Ark*. In 1921, he began to offer auto ferry service.

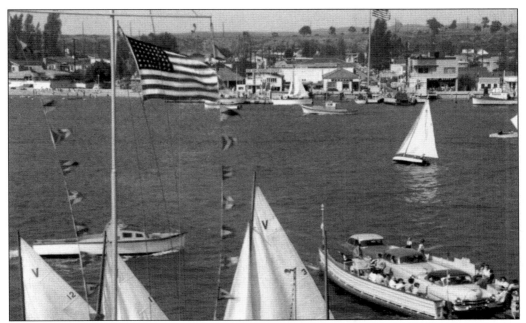

NEWPORT HARBOR AND BALBOA ISLAND, C. 1957. Over the years, the Beek family has made a practice of giving their boats colorful names, including *The Fat Fairy, The Joker, Square Deal,* and *Islander.*

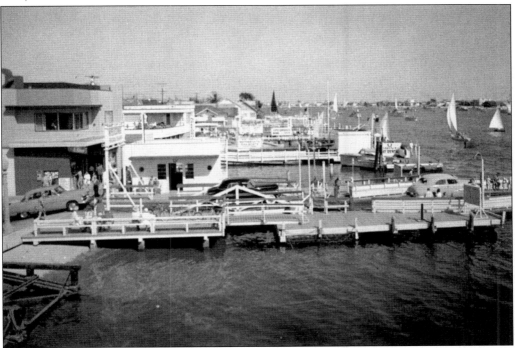

FERRY LANDING ON SOUTH BAY FRONT, BALBOA ISLAND, C. 1958. Passengers arriving from the Balboa peninsula can explore the island's quaint shops and restaurants or move on to Pacific Coast Highway and nearby Corona del Mar.

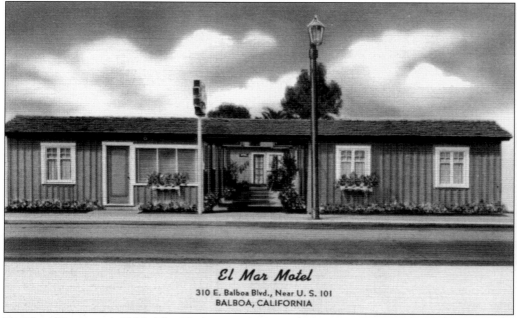

El Mar Motel

310 E. Balboa Blvd., Near U. S. 101
BALBOA, CALIFORNIA

EL MAR HOTEL, C. 1954. The El Mar Hotel was "a scrupulously clean modern motel with or without kitchens and refrigeration. 1 block from ocean, 2 blocks from beautiful bay, 3 blocks from city attractions." This building still stands today, but like many other old motels in Balboa, it has been converted to apartments.

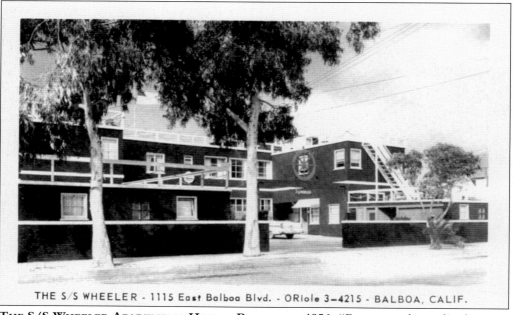

THE S/S WHEELER - 1115 East Balboa Blvd. - ORIole 3-4215 - BALBOA, CALIF.

THE S/S WHEELER APARTMENT-HOTEL, BALBOA, C. 1956. "For sea, sand, or solitude, come to America's famous Newport Harbor." The S/S Wheeler was located right on the beach, three blocks east of the Balboa pier. Today a private residence occupies the spot.

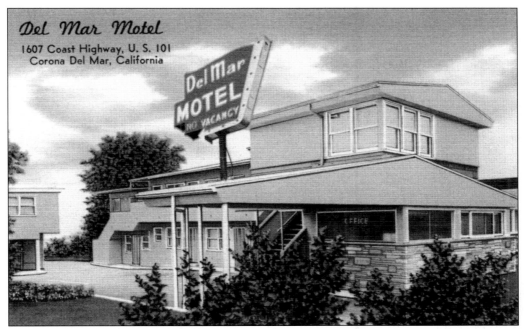

Del Mar Motel
1607 Coast Highway, U. S. 101
Corona Del Mar, California

DEL MAR MOTEL, C. 1954. "If for a night, weekend or week, a warm welcome awaits you at the Del Mar Motel."

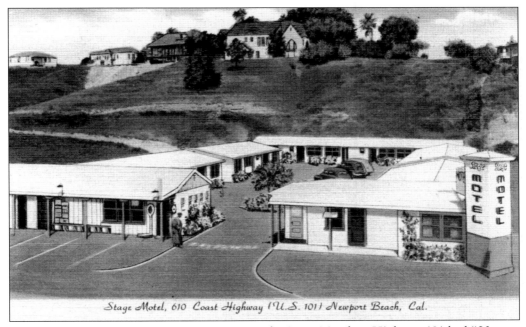

Stage Motel, 610 Coast Highway (U.S. 101) Newport Beach, Cal.

STAGE MOTEL, NEWPORT BEACH, C. 1955. The Stage Motel on Highway 101 had "23 new, modern units, all with showers and radios. Some with kitchenettes and twin beds."

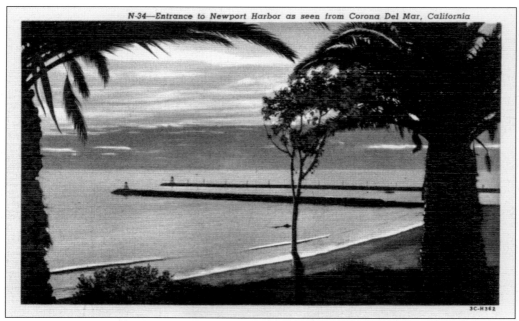

3C-H362

ENTRANCE TO NEWPORT HARBOR AS SEEN FROM CORONA DEL MAR, C. 1953. While the extension of the jetties in the late 1930s killed surfing in Corona del Mar, it also created "The Wedge" at the end of the Balboa peninsula. As waves approach the shore, they bounce off the jetties' boulders and merge into unpredictable, backbreaking waves feared by body boarders worldwide. It is known to some as "the biggest jolt of natural adrenaline in all of Southern California."

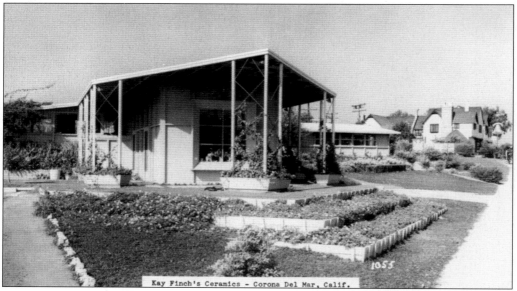

Kay Finch's Ceramics - Corona Del Mar, Calif.

KAY FINCH'S CERAMICS, CORONA DEL MAR, C. 1952. From 1939 to 1963, artist Kay Finch created hundreds of art pottery figurines, vases, banks, and planters. Her art depicted canine, feline, pastoral, woodland, zoological, holiday, nursery, and human subjects. In the years since, several books have been published on the artist and her work.

118

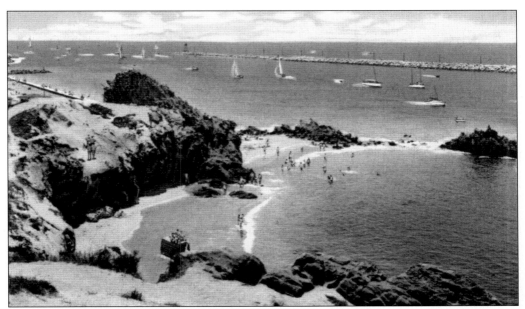

ENTRANCE TO NEWPORT HARBOR, C. 1952. In 1931, construction began on an automobile tunnel linking the end of the peninsula to what is now Corona del Mar State Beach. Speculation of shoddy construction, combined with the March 1933 earthquake, resulted in its collapse. The Corona del Mar tunnel quietly faded into history.

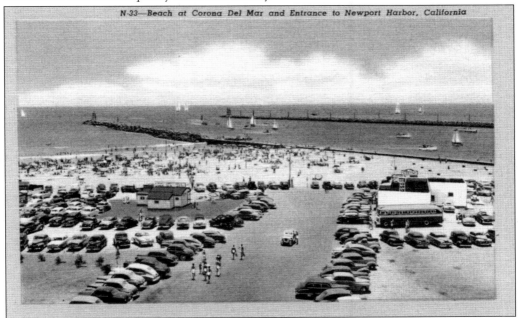

BEACH AT CORONA DEL MAR AND ENTRANCE TO NEWPORT HARBOR, C. 1953. In the early 1940s, this beach was owned by Citizens Bank of Los Angeles, which intended to sell lots for development once the land had appreciated. City watchdogs Isabel Andrew Pease and Mary Burton worked tirelessly to have the beach set aside for the public's use. As a result of their efforts, residents and visitors enjoy the beauty of Corona del Mar State Beach.

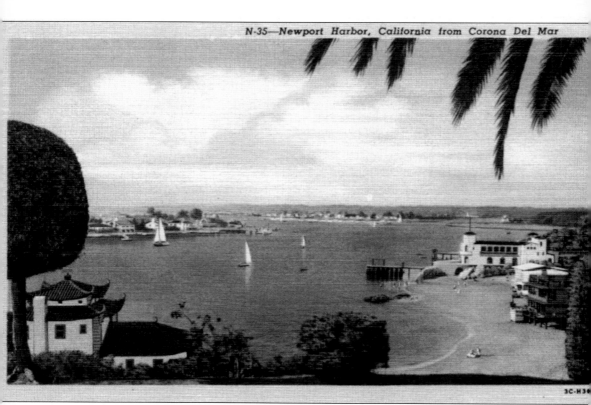

NEWPORT HARBOR FROM CORONA DEL MAR, C. 1953. Newport Harbor is three miles long and three-quarters of a mile wide.

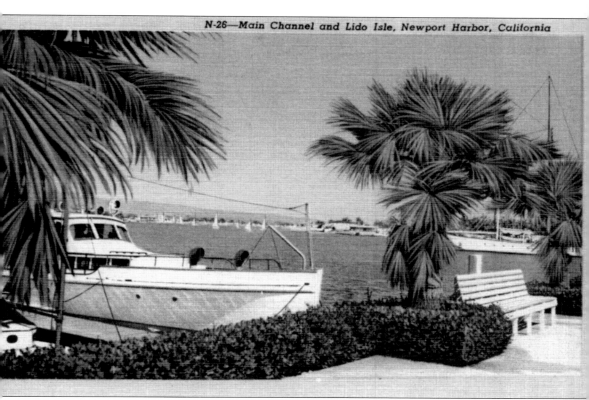

MAIN CHANNEL AND LIDO ISLE, NEWPORT HARBOR, C. 1953. In its early years, Lido was known as Electric Island, or Pacific Electric Island. In 1923, W. K. Parkinson, a conductor for the Pacific Electric, fell into some money and bought Lido. Lots were slow to sell, and much of the island remained undeveloped until after the war.

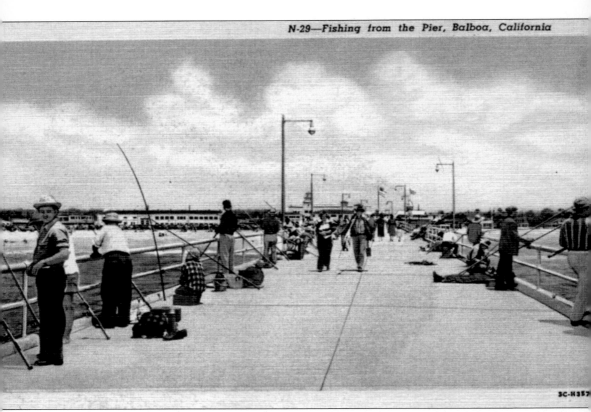

FISHING FROM THE PIER, BALBOA, C. 1953. Fishermen were likely to find a variety of different fish at the end of their line, including tuna, albacore, sea bass, yellowtail, barracuda, and halibut.

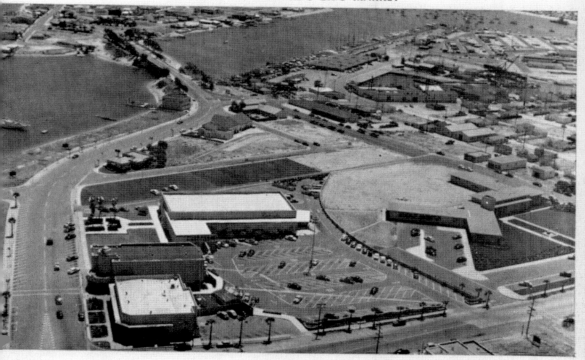

AERIAL VIEW OF RICHARD'S LIDO MARKET, NEWPORT BEACH, C. 1955. Opened in 1946, the market's motto was "Service, Variety, Quality and Honesty." This unique shopping experience, which included an organist playing shoppers' requests, earned the store the 1954 "Retail Store of the Year." Also visible is the Lido Theatre, built in 1939 and still going strong today.

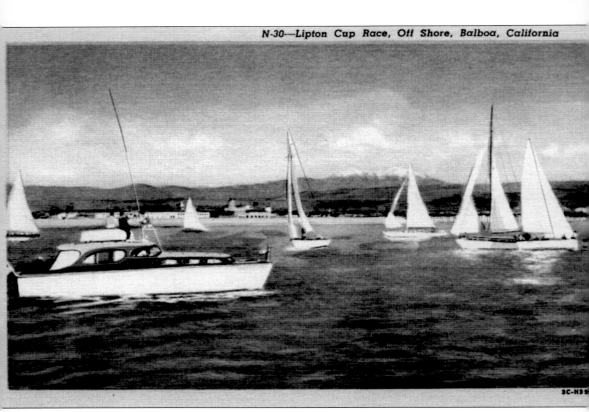

LIPTON CUP RACE, OFF SHORE, BALBOA, C. 1953. Tea entrepreneur Sir Thomas Lipton donated the cup to the winner of this series of three Pacific coast races. In 1947, the Newport Beach Voyagers Yacht Club was the victor.

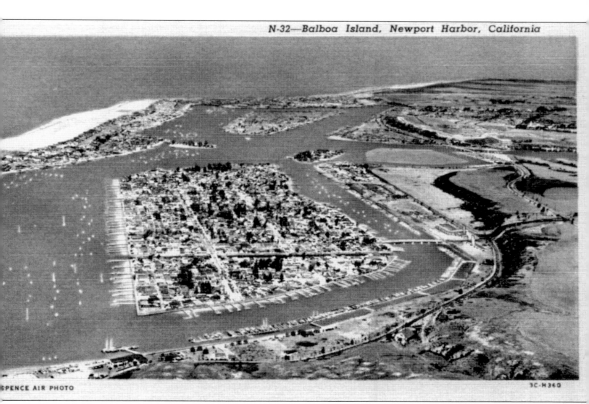

SPENCE AIR PHOTO 3C-H360

BALBOA ISLAND, NEWPORT HARBOR, c. 1953. From 1935 to 1942, only 15 percent of the houses in Newport were occupied in the winter months. By the mid-1950s, 85 percent were occupied year-round.

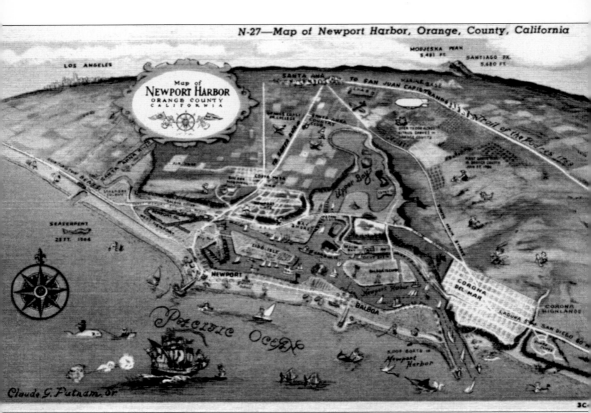

MAP OF NEWPORT HARBOR, ORANGE COUNTY, C. 1953. This aerial map notes several interesting features: the "site for hospital" where Hoag Presbyterian would soon be built, 5000 boats in Newport Harbor, and the 23-foot sea serpent caught in 1904, later identified as a rare oar fish.

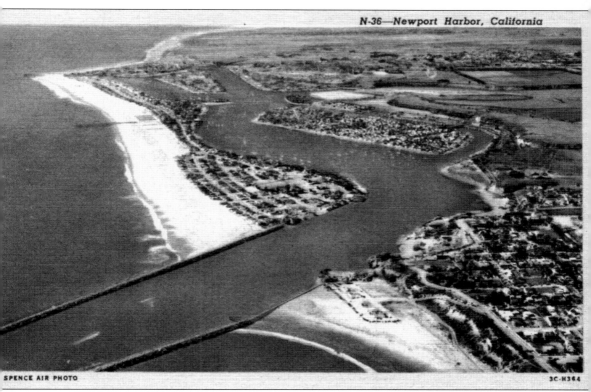

SPENCE AIR PHOTO

3C-H364

NEWPORT HARBOR, C. 1953. When you need to get away, come enjoy Newport's seven miles of oceanfront beaches. Sail its bay. Explore its islands. Go to the Fun Zone, and share a Balboa Bar with a friend. But come with the clear and certain knowledge that once you've arrived, you will never want to leave!

BIBLIOGRAPHY

Castle, Ramona Duarte. *Old Newport: The Seaport Years*. Newport Beach, CA: Sandpiper Press, 1970.

Felton, James P. *Newport Beach: The First Century, 1888–1988*. Brea, CA: Sultana Press, 1988.

Gray, Pamela Lee. *Newport Beach*. Charleston, SC: Arcadia Publishing, 2003.

Lee, Ellen Kay. *Newport Bay: A Pioneer History*. Fullerton, CA: Sultana Press, 1973.

Meyer, S. A. *Fifty Golden Years: The Story of Newport Beach*. Newport Beach, CA: Newport Harbor Publishing Company, 1956.

Sherman, H. L. *History of Newport Beach*. Los Angeles, CA: Times Mirror Press, 1931.

White, Nibs. *Once Upon an Island*. Balboa Island, CA: Nibs White, 1994.